MAGNIFICENT OBSESSIONS

Magnificent

Twenty Remarkable Collectors in Pursuit of Their Dreams

Obsessions

Mitch Tuchman

Photographs by
Peter Brenner

CHRONICLE BOOKS

SAN FRANCISCO

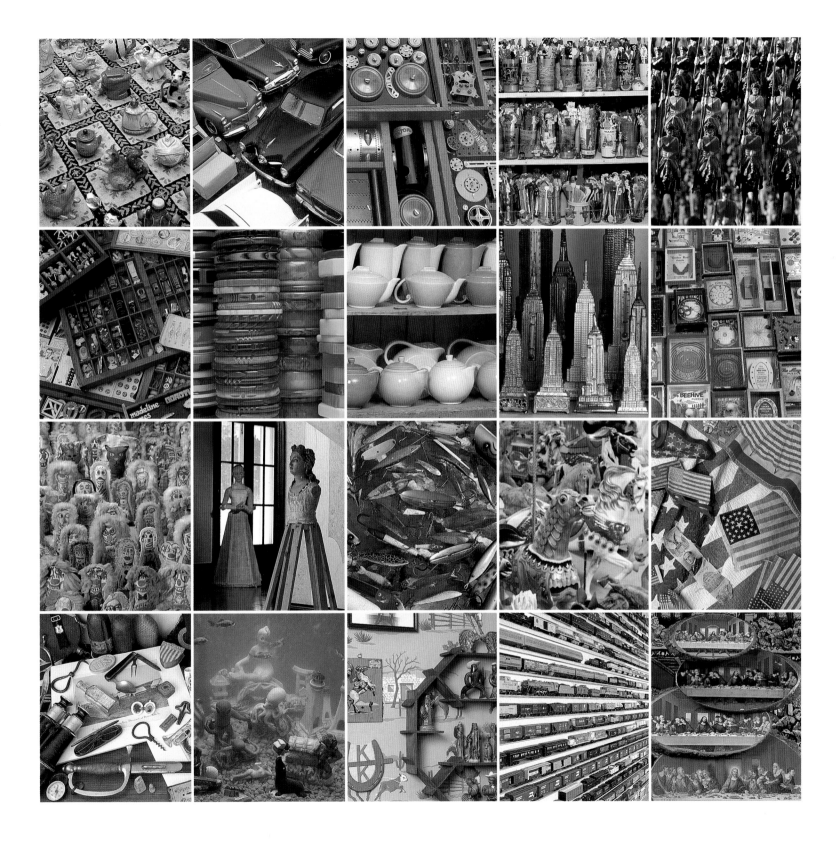

Copyright © 1994 by Mitch Tuchman.
Photographs © 1994 by Peter Brenner.
All rights reserved.
No part of this book may be reproduced
in any form without written permission
from the publisher.

Printed in Hong Kong.

LIBRARY OF CONGRESS
CATALOGING-IN-PUBLICATION DATA

Magnificent obsessions : twenty remarkable collectors
in pursuit of their dreams / Mitch Tuchman ; photographs
by Peter Brenner.
 p. cm.
ISBN 0-8118-0360-0
1. Collectors and collecting. I. Tuchman, Mitch. II. Brenner,
Peter, 1950– .
AM231.M27 1994
790.1'32—DC20 93-21481
 CIP

EDITING: Suzanne Kotz
BOOK AND COVER DESIGN: Jim Drobka
IMAGE SETTING: PrePress Studio, Inc., Los Angeles
COVER PHOTOGRAPHY: Peter Brenner

Distributed in Canada by Raincoast Books
8680 Cambie Street, Vancouver, B.C. V6P 6M9

10 9 8 7 6 5 4 3 2

Chronicle Books
275 Fifth Street
San Francisco, California 94103

Introduction

9

Contents

Leonore Fleischer	**Robert and Stephen Cade**	**Arlan Coffman**	**Norma Hazelton**	**Ed Ruby**
12	**18**	**26**	**33**	**40**
Figural teapots	*Studebakers*	*Construction toys*	*Swizzle sticks*	*Toy soldiers*
Dorothy Twining Globus	**Meredith Brody**	**Bill Stern**	**Steve Schwartz**	**Jerry Slocum**
49	**57**	**62**	**69**	**75**
Everything	*Bakelite jewelry*	*Vernon Kilns pottery*	*Souvenir buildings*	*Puzzles*
Clare Graham	**Patricia Geller**	**Mike Farrior**	**Lorinda Bray**	**Kit Hinrichs**
83	**88**	**94**	**103**	**109**
Carnival punks	*Mannequins*	*Angling equipment*	*Carousel horses*	*Stars & Stripes*
Marius Péladeau	**Mark Wiskow**	**Ruby Montana**	**Mike Stella**	**Susan Caroselli**
114	**121**	**125**	**130**	**139**
Civil War memorabilia	*Aquarium furniture*	*Wild West*	*Lionel trains*	*Last Suppers*

Introduction

hen the American painter and naturalist Charles Willson Peale (1741–1827) painted his self-portrait in 1822, he depicted himself lifting a curtain on his Philadelphia museum, a conglomeration of painted portraits and sculpted busts, fossils and mineral specimens, 4,000 mounted insects, 1,600 stuffed birds and no less than 90 species of mammal, the reconstructed skeleton of a mastodon he himself had unearthed in upstate New York, and a wealth of ethnological curiosities from the farflung reaches of the globe installed floor to ceiling in the long, second-story gallery of Independence Hall for the edification of the public. Nature, according to the egalitarian view of the day, was an open book, in which the masses by their own observation might gain enlightenment. Peale's obsession had become so all-consuming that he abandoned art as a career and devoted himself entirely to his collection and its display.

When Orson Welles "painted" his hypothetical caricature of William Randolph Hearst (1863–1951), he restyled the magnate's merely palatial San Simeon as the gargantuan Xanadu and in the simulated newsreel that opens *Citizen Kane* listed its contents as "paintings, pictures, statues, the very stones of many another palace, a collection of everything so big it can never be catalogued or appraised." Kane's collection begins as the commonplace souvenirs of a Continental honeymoon, amassed

in breathtaking excess. Speculation mounts as the film progresses that his acquisitions from that point onward address a need unnamed and perpetually unmet. A concluding tracking shot picks out, haphazardly stacked among thousands of anonymous crates, candelabra, lamps, assorted orientalia, urns, oil jars, globes, tables, bundled carpets, a throne, a printing press, a gramophone, a bedstead, memorabilia of a family lost and longed for, and most precious of all, his boyhood sled, Rosebud, symbol of an Edenic life unencumbered by wealth and position.

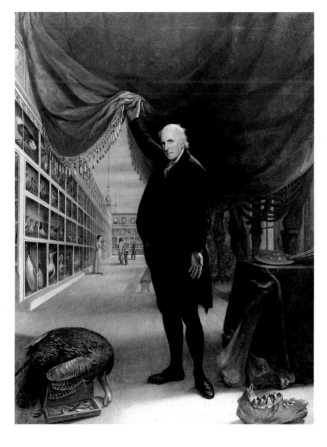

In certain plainly evident ways Peale and Kane were opposites. Peale carefully selected items for what they contributed to an overall view of the natural universe. Kane simply accumulated. Peale conceived and constructed the perfect setting for each object. Kane never bothered to unpack. Peale's inclination was to share, even to proselytize; Kane's, to isolate himself and his horde. Yet in one basic way they were identical: whether they sought enlightenment or solace, their collections obsessed them, compelling their ceaseless increase.

There are aspects of both Peale and Kane in all collectors: a capacity to derive emotional or intellectual stimulation from objects; a desire not merely to see but to possess; a fickle heart that swears devotion to one thing, then coolly courts another; equanimity in the face of burgeoning numbers; a facility for bringing order to a chaotic universe and the vision to construct a reasonable explanation of it; the willingness to allocate time and resources to the illusive goal of completeness; and the conviction that one's folly is meaningful, justified, even requisite to the improvement of humankind.

There is almost nothing that someone does not cherish enough to collect. For every collector of cars, there's a collector of trains or boats or bicycles. To the twenty collectors included here we could easily have added collectors of furniture of every make and description in colonial, period revival, and more recent European and American styles; candleholders, oil-burning and electrified lamps, and flashlights; flatware and hollowware in silver, silverplate, copper, hammered aluminum, and base metals; blown and molded glassware, cocktail shakers, marbles, and insulators; imported porcelains and domestic stonewares, pottery of the arts and crafts movement, cookie jars, pie birds, and ashtrays; wood and Bakelite radios; Victrolas; musical instruments and music boxes; clocks and watches; jewelry; needlework, beadwork, and vintage clothing;

10

Charles Willson Peale
(1741–1827)

The Artist in His Museum
1822
Oil on canvas
103 3/4 x 79 7/8 in.
Courtesy of the Pennsylvania
Academy of the Fine Arts,
Philadelphia
Gift of Mrs. Sarah Harrison
(The Joseph Harrison, Jr.
Collection)
1878.1.2

pieced, appliquéd, and quilted bedcovers; Indian blankets and baskets; windup toys and long-forgotten board games; dolls, dollhouses, and birdhouses; still and mechanical banks; architectural ornaments and hardware; political, military, travel, holiday, and sports memorabilia; paintings, sculpture, and silhouettes; tramp art; shell art; glow-in-the-dark; visions of the future past; measuring devices and patent models; telescopes, microscopes, kaleidoscopes, and cameras; calendars, papier-mâché, postcards, baseball cards, and comic books; advertising and salesman's samples; antlers and taxidermy; Disneyana and Nixoniana; the embroidered booties of Chinese concubines; nozzles, ornamental lawn sprinklers, and more.

Treasures and trash, big things and small, new things and old—more often old. Collectors bend toward a liberal definition of the antique, a populist view that has little to do with the date of a piece, its rarity, or price. An antique is simply an object from an era irretrievably, if not distantly, past. Its desirability derives from a time dimly cherished, transformed thus by context from the merely secondhand.

We were not as interested in collections as in collectors, and though we avoided the temptation to hypothesize universals, one common trait made itself overwhelmingly apparent: the collecting bug is a tenacious, irresistible critter. "It's one of those things," collectors told us bemusedly, "you don't know when to quit." Even when they spoke of it as a "disease" or compared it with a "drug habit," they seemed decidedly unperturbed.

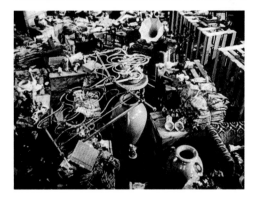

No single question seemed suitable for everyone, but we went prepared to ask: When did an accumulation become a collection? Do you think in terms of the individual object or the collection when you buy or trade? What are the feelings associated with an acquisition? What is the toughest item to find? Is there one you looked for for years? When you found it, how did you feel? Is there a point at which price overrules passion? Do you ever ask yourself, "Why do I do this?" or say, "I'm not going to do this anymore?" and when you do go back for more, how do you explain it to yourself? When is a collection complete? What is the meaning of *enough*? What do you imagine the future of this collection to be? Is it too late for beginners?

What follows are the answers of the twenty wonderful people we visited and pictures that can convey only partially what they have accomplished with patience, perspicacity, enthusiasm, and consummate care. •

11

Leonore Fleischer

Magazine columnist and novelist

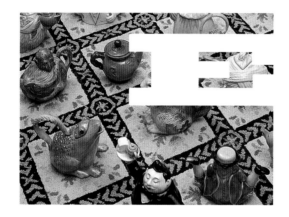

ven before I really knew Leonore Fleischer, we had gone antiquing together. Our mutual friend, Larry Ashmead, himself known to New York magazine as one of that city's greatest shoppers, had called to tell me that Leonore would be in town working on a book, her umpteenth, and would I mind spending an afternoon taking her on a tour of collectors' haunts in L.A.? Among her purchases that day was a beaded firescreen depicting an American eagle. That screen joined what I've since discovered is an impressive collection of antique American beadwork, needlework of every description, man-in-the-moon graphics, Disney this and Disney that, fish and game dinnerware sets,

12

and figural teapots. When I came by to interview her, she had recently consolidated the contents of two homes into one and was, understandably, wondering how to cope with the accumulated treasures of a lifetime.

"I said to my friend Larry the other day, 'Larry, what's going to happen to our stuff when we die? Nobody wants it.' I have my china and my teapots and my man-in-the-moon stuff and my linens—there are trunks full of embroidered linens. What's going to happen to it? I have one child. He is a son. He has one child, who is a son. Alex hates my stuff. He hates even to look at it.

"I think that as I get on in life, what I will have to do is deaccession. I don't know when I'm going to start, because I'm on in life already. I hate the thought of selling, but I suppose that's what I'll have to do.

"Larry told me that he has it in his will that I get his salt and pepper shakers. I said, 'Then, Larry, you must never die.'

"A Viking ship burial, that's what we want. We want to be loaded up on a great, big barge, put out to sea, and the whole thing set alight. Oh, sure, but my barge would sink an inch from the shore.

"Collecting is a disease. I don't have to tell you that. It's a poison that enters your bloodstream. I'm less addicted to it now than I used to be, because I've traded up so that everything I collect or used to collect is too expensive for me to buy anymore, and I'm not satisfied with the cheap stuff.

"Every now and again Larry and I play hooky for special occasions like the East Coast Collectibles Show in West Stockbridge, Massachusetts. It's a fabulous show, more manageable than the Brimfield flea market. At Brimfield you always have the feeling that down at the next space someone is buying something that really belongs to you, and you'll never get there in time. There's a kind of desperation about Brimfield that I can't deal with, but West Stockbridge I can.

"Larry and I used to go to auctions on Saturday nights. We could come back with fifty things from an auction. Suddenly I look around, and every surface is covered. I'm going to strip the kitchen as soon as I finish the novel I'm working on. Out go the cookie jars. Out go the tins. Enough is enough. I want to clear this stuff away. I want to start breathing."

"How I started on my teapots. Many years ago a new flea market opened on 51st Street in New York City. I was living in New York then, so I went. It was a beautiful day, and everybody had set up tables and was selling things, and I bumped into a woman I used to work with at *Publishers Weekly*. She was there representing her church. They had a table with odds and ends, and on it they had a cat teapot, cat-shaped teapot, and the coloring caught me, because it had the coloring of my beloved cat, Edith. I said, 'I would like to buy it,' and she said, 'For you, $4.' I'll never forget that because when you're being pushed to an addiction, the first taste is always free. So my first teapot was just $4, and I only bought it because it looked like Edith. I still have it. I don't remember how the second or third one came. But suddenly I was collecting figural teapots.

"I'll tell you something, Mitch. What happens is, you go into a fugue state, and when you come out of it, you've got sixteen or seventeen or twenty or thirty of whatever it is you're collecting. When you're investing four bucks here and eight bucks there, you don't really keep score.

"What makes a figural teapot is that it's in the shape of a figure instead of in the shape of a teapot. The best ones are truly figural. For example, the squirrel is figural completely, because the handle is his tail and the spout is a nut clutched in his paws. There's no part of that teapot that isn't squirrel. The frog, on the other hand, is charming, but it's not fully figural, because the handle is extraneous. On the lady the handle forms the basket, and that Chinese man is totally figural, because his nose is the spout and his queue is the handle. The bather I think is wonderful.

"I want to point out two things. Today figural teapots are quite common—you can buy them everywhere—but when I started collecting in the mid-'70s, figural teapots were a thing of the past—the 1940s, the 1930s, the 1950s—and they were rare. They were hard to find, but they weren't very expensive when you found them. Eight bucks.

"Then Fitz & Floyd began to bring out limited editions of figural teapots made rather cheaply in Japan, and I started buying those. More and more I found them at flea markets. The next thing I knew, I had a really large collection. And then I started to go for the more expensive, rarer pieces. For example, the little bisque one—the badger with a little badger on its back [BOTTOM, RIGHT]—was $210. The lady with the basket: they were asking $140, and I think we got it for $95."

"It sounds like you got a bargain. How do you do that?"

"You have to start out by complimenting the dealer. What you say is, 'Oh, I love that piece. It's so beautiful. I hope I can afford to buy it. I wish it could be mine. If we both work hard enough at it, it will be mine. You won't have to pack it up again and take it home from this show and maybe break it on the way.' You have to do it politely. It's foolish when people denigrate a piece: 'Oh, it's chipped' or 'I don't like this' or 'that.' You set yourself a price that is fair, and you have to be prepared to walk away, not to cave in or knuckle under. And people are always accommodating. Well, they're usually accommodating. Sometimes they say, 'No, I have almost that much in it myself,' and you have to be prepared."

"Have you ever gone out on a limb for a teapot?"

"There was one in one of those antique centers in London, and it was so far above what I could expend. I hung around, and I stared at it, and I went away, and I came back, and I went away again, and I came back again, and I looked at it. Everything in my heart wanted to buy it, and everything in my head said, 'You can't. You really can't. It's just absolutely beyond your reach.' And I'm happy to tell you that today I don't remember what the figure was. Maybe I blocked it out of my mind. However, I do remember the agony of wanting it so much.

"On the other hand, in a Madison Avenue shop I saw a set of miniature Chinese pieces, and it was $3,000. Just charming. Then in an outdoor flea market in upstate New York I found a tiny handful of that set for $30. Now, yes, I'd rather have the

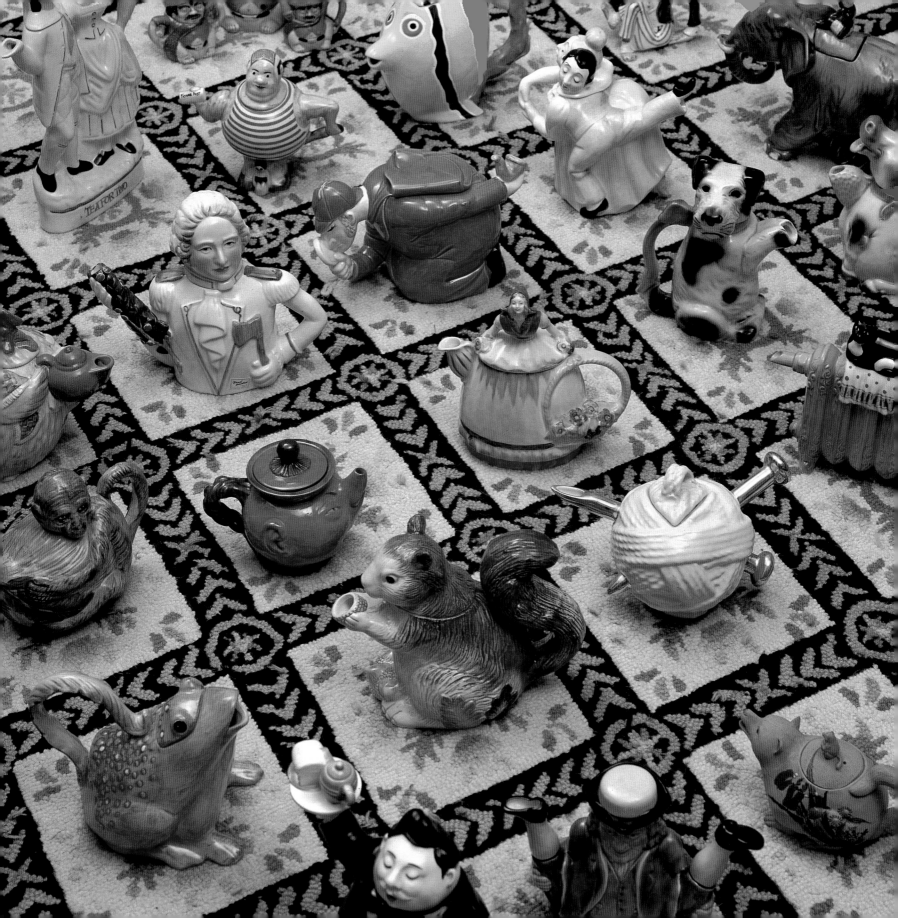

The cats are the largest subcategory within my collection. I think that's because they're fairly common in the marketplace. They've been made as long as figural teapots have been made. I think that's because cats are domestic, and tea is domesticity, and there's a kind of a natural confluence of the two. Also a lot of teapots are English, and the English are notoriously fond of pussycats. The lion [CENTER SHELF, RIGHT] is certainly British. The first, second, and fourth from the right on the back of the lower shelf are by Tony Wood; they're British. They seem to be from the same mold with different painting on them.

"I think Edith [TOP, RIGHT], the $4 cat, the first one I got, is probably the oldest in this group. It's still the best cat I have. It's the best looking, and I never saw another one like it. "

whole set, but, no, I wouldn't. I'd rather have that little handful for $30 than the whole set for $3,000.

"I like to see my teapots here on the shelves. They're like little people. They're like little friends—without going overboard. But when I look at them, they make me smile, some more than others. My collection amuses me. At Thanksgiving I had my Thanksgiving teapot on the table. When I had my Christmas party, I had my Christmas teapots out. I like playing with them.

"There's something about a teapot that is very cozy. It suggests sitting down, putting up your feet, chatting with a friend. Warmth. Indoors. Firelight. Drawing the curtains as the day dies. I think those are all elements in teapots. Then, of course, china has always been treated whimsically."

"You mentioned that along with collecting teapots, one gets involved with collecting tea accoutrements. What are those?"

"I have tea strainers, several that are silver and very pretty and several that are patented to be unusual. Then there are all kinds of boxes that say, 'Tea.' In the early days tea was precious, and you bought a box that locked so that the servants couldn't steal your tea. I have tea caddies. I have caddy spoons, all kinds of caddy spoons. I have a beautiful one for the coronation of Edward VIII, who, as you know, was not coronated; he married Mrs. Simpson instead."

"Collecting is making a commitment to share your life with certain objects. When you adopt an animal as a pet, you make a commitment to make that animal part of your

life. In the same way you make a commitment to make these things a part of your life, so you'd better love them when you buy them. You're not going to learn to love them. You have to love what it is you buy and buy only what you love." ●

Robert Cade

Nephrologist and inventor of Gatorade

Stephen Cade

Automobile restorer

o one of a certain age can forget the Studebaker Starliner. It looked like a jet plane coming toward you and a locomotive going past. The design said speed no matter where you stood. Affectionately known as a bullet-nose (or two-row corn picker), there never was a more stylish vehicle. A collection of Studebakers was my idea of heaven until I found out from Robert Cade and his son Stephen just what having the odd hundred entails. A lot of work.

ROBERT CADE: "When Stephen was small, he wanted to work on cars, so I bought an old VW that had been run without oil. The motor was ruined, and there was quite a bit of rust on it. We bought one of those Chilton's repair manuals, and Stephen and I rebuilt that car. When we finished it and it ran, it was really as big a thrill as when I did my first kidney transplant. We did several more VWs that way, and each one we finished we gave away.

"Our family car at the time was a 1951 Studebaker—I don't know if Stephen showed you Old Spot—which I bought in 1958. For a long time I drove it everywhere: to meetings in New York and Indiana and Pennsylvania and Texas. It has roughly

18

380,000 miles on it. Anyway, Stephen and I decided, if we were going to work on cars, we might as well work on something a bit unusual, so we started doing old cars. Old Spot was the first, and then we got a '55 four-door v/8, and we did it; it's another one that we gave away. As the cars started looking better and better, it was harder and harder to give them away, so we started keeping them.

"I'm not sure what the appeal is, but when one drives a GT Hawk down the street, there are not many heads that won't turn. Or an Avanti. Really any Studebaker. The Lark is the Plain Jane of the Studebaker family, but if you drive a restored Lark down the street, all the heads turn. You sort of feel proud that that's your car. And if it was restored in your own shop and you got your hands dirty and cut up doing it, then it means a little bit more.

"There are boys who work with us on the restorations. We pay them to work. We give them a car and buy the parts for it, and when they've finished, they have a restored car that they did the work on, and we've got someone else who's interested in what we're interested in. With Stephen and Derwood Thompson looking over their shoulders, the work has been done well.

"These are both 1954 Conestoga wagons [RIGHT], named after the Conestoga that the settlers took from the Midwest to the West Coast. John Studebaker made those wagons from 1837, before the company was even formed, and continued making them into the '70s. In the 1860s most of the production was for the Union army. These station wagons have v/8 engines in them, 232 v/8s. In their day I think they were the best v/8s made in this country, better than Cadillac or any of the others.

"The car on the right was kept under a tree that peacocks roosted in. Everything from the front doors back is in good condition. It's not going to be the easiest restoration, but we've done cars that were worse.

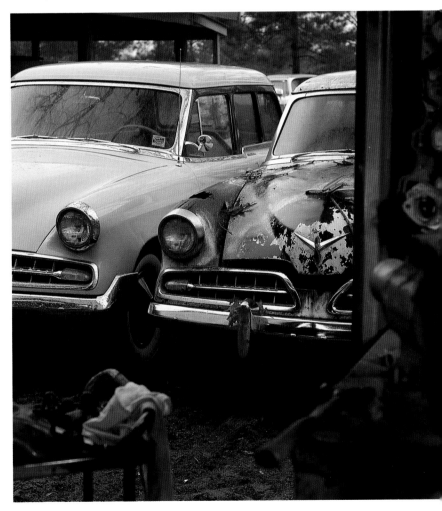

"If you restore an old car and try to sell it, unless you're an awfully good business-man or find a real nut, you're not going to get as much out of it as you put into it. There are some that we should sell for $4,000 or $5,000 more than we have in them, but if you have $15,000 in a car and you spend a year restoring it and charge a $4,000 markup, all that does is increase your income tax. After you've spent a fair amount of money and an awful lot of time on it, selling your car doesn't seem a very appealing thing to do. So now we're talking about a museum."

STEPHEN CADE: "Old Spot is the first Studebaker Dad ever bought. It's a 1951 Champion, what they call a bullet-nose, and he got it in Hackensack from a friend of a friend. This guy was a postal worker who'd lost his space in the parking lot at the post office but couldn't remember to feed the meter out front and got so many $5 parking tickets that he decided to give up driving to work and take the bus. He took the car to a junkyard, and they offered him $10. Dad needed a second car, so he said he'd buy it. When he got the car, it had a case of oil and a chamois cloth in the trunk. A day or two later Dad drove from New York to Chicago and used the case of oil. It's Old Spot because it left oil spots all over.

"Dad thought that bullet-nose was a pretty good car, so later he bought a '57 wagon, a year old. That was a good car too, and he traded it for a '64 wagon new. Then we just had two Studebakers until 1972.

"We had our cars serviced at a place called Halverson's Garage, and Dad told the guy there that what he really wanted was a '53 Starliner hardtop. 'Well, I'll start looking,' he said, and before long he found a '55 two-door sedan. Dad said, 'Well, I guess that'll be close enough,' so he got it—we still have it—but he still wanted that '53. We found one in a junkyard that was beyond hope, and we found another, but it wasn't a hardtop. But once we'd bought those, every time we went to the garage, the guy would say, 'I saw another Studebaker,' and we'd go look at it. Thirty-five, fifty, a hundred dollars, and we'd buy it. We got up to six or eight cars, and we stayed that way for ten years. Then we put this place up, the original barn, and we got carried away. We started buying everything. If the prices were right, we'd buy them. If there were particular models we wanted, we'd buy them. We got to where we liked them more and more, and it just got out of hand. My mother used to get real uptight about it, bringing junk cars home. She's given up now.

"We collect anything that's Studebaker. I acquire the junk ones; the nice cars are his. Dad probably has a favorite year. I don't. I like them all about the same. I like the barebones Scotsman as much as I like a Hawk. As far as collecting, really I collect aimlessly. If it says Studebaker on it, I want it. Dad's a lot like that too.

"Most guys collect just Hawks or just Avantis, or they'll collect completely different models. They don't have duplicates, where we'll buy ten of the same car; it doesn't matter. Even so we want to have cars from every era. Where Studebaker made major styling changes, we like to have that. Dad wants to buy a Studebaker electric car and a 1911 or '12 Flanders. Those are the only two we're looking for. He said that after he buys those, he's not going to buy any more, but we've probably bought ten cars since he said that. There've been a few that we've bought just so they wouldn't go to the crusher."

"We like to go to shows to visit with other collectors and discuss Studebakers. We go to buy parts. We go for the trip. We'll drive nine or ten cars there. All of us drive: the guys who work out here and two of my sisters. My ex-wife drove. The kids drove. Mom and Dad drive, and then they'll invite friends. There'll be twenty to twenty-three of us.

"Along the way we get a lot of attention, a lot of stares. People are real surprised to see all these cars coming. They probably think we're a bunch of idiots.

"The only thing that's not fun is when we have car trouble on the side of the road. This last year we didn't have any to speak of. Other years we've had a lot. Once we all drove to Springfield, Missouri. We'd driven all day. It was five or six o'clock, and a fuel pump went bad on a 1964 Cruiser and filled the motor full of gas. It left us on the side of a two-lane road. We were out there till ten that night getting it fixed. The very next day the arm fell off the replacement pump, so we were stranded again. One year on the way to South Bend my sister's Hawk stripped a timing gear. We fixed that one in the motel parking lot, out in the hot sun."

"*What kind of parts do you take when you go to a show?*"

"We take a timing gear and the gaskets for that, three or four water pumps, about the same on fuel pumps. We take extra master cylinders. We take flex plates for automatic transmissions, and all the tools to fix them. We take touch-up paint for all the cars, a lot of cleaning supplies. This year we'll probably take motor bearings and ring sets, the whole nine yards, and probably an extra transmission or two just in case we need them. We'll take parts for each car. We'll take spare alternators, generators, starters, that kind of thing. We're pretty well prepared to fix anything that goes wrong."

"*How are you doing at these shows?*"

"We win."

21

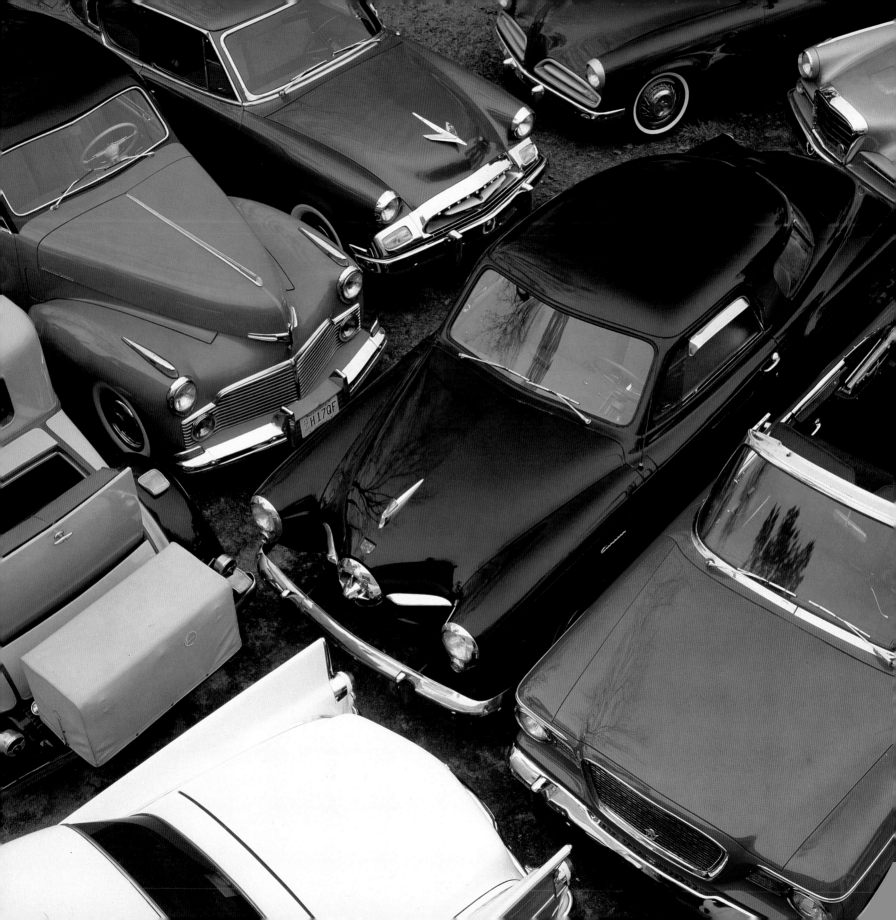

ROBERT CADE: "The maroon car [CENTER] is a 1950 Champion Starlite coupe with the wraparound window in the rear. Raymond Loewy designed it. Today it's probably Studebaker's most popular model. The bullet-nose was inspired by the P-38 of World War II, which had two engines and the cabin in between.

"The dark green '53 [TOP, RIGHT] is also a Champion. I think that model is the prettiest car that Studebaker or anyone else ever made. It's not all chromed up so it looks gaudy. The lines are very smooth and functional. It's the first car we really restored out here. We did it about 1980, and there's almost no rust coming through yet, so we did a reasonably good job.

"The red convertible we bought just two years ago from a friend in Mississippi. It's a 1960. When we get around to restoring it, it will all be stripped down, sand-blasted, treated with phosphoric acid to make sure all of the rust is gone, then repainted and reassembled.

"The car in front is a '58 Silver Hawk. These big fins came in '57 and lasted through '61. The finned Hawks are becoming very popular. You drive one down the street or into a service station, and everybody wants to know what it is. Initially I really didn't like the fins. I thought, 'We'll take the fins off and make it a better-looking car,' but I've gotten so I sort of like them.

"The pale green car is a 1942 Skyway Commander. It's got a straight 8 engine in it. We bought it from Carroll Studebaker [a collector from a non-auto-making branch of the family] and drove it here eighty miles an hour. The '31 Dictator coupe with the rumbleseat we got from Carroll also. Dictator was a good name until Hitler and Mussolini and Stalin. They dropped the Dictator line in 1937 because of them. The interior is all original. The dash is worn in places. If you show it, you lose points on something like that, but I can't see ripping an interior like that out. We've had a lot of trouble with this car. The water pump leaked. The lights didn't work. The brakes we've done and still don't have right. It hadn't been driven in nine years when we got it. Cars go downhill sitting faster than they do if you drive them.

"That dark red car [TOP, LEFT] is a 1955 Commander two-door sedan. It was our family car for about five or six years after we got it. We named it Hesperus. It had been wrecked, not badly, but the rear quarter panel was all bashed in. There were a number of other dents. The engine had a burnt bearing. There was an awful lot of rust. The chrome was bad, and it reminded me of the poem 'The Wreck of the Hesperus' that I learned when I was in high school. We changed the drive train around a little bit and put a different rear end in it. That car will go 130 miles an hour. This is the third color that we've had on it. Some of the guys that work with me think that's the prettiest car they've ever seen."

ROBERT CADE (IN DUSTER): "Studebaker made this doctor's chase [RIGHT] from 1880 to 1904, so there's no way of telling what year this one is. The body is mahogany. The wheel spokes are mahogany. The Studebaker name is on the step plates on both sides.

"The blue car is a seven-passenger touring car, the 1916. This and the green 1928 Erskine next to it are both four-cylinder engines, but the 1916 is twenty-eight horse-power, and the Erskine is about forty horsepower. You had to have plenty of muscle to drive the '16. It's got old leaf springs in the front. It's hard to turn. The Erskine is almost a pleasure to drive by comparison. I took it to the autocross a couple of years ago and drove it through the quarter of a mile in forty-four seconds.

"The red truck was bought by a farmer in Michigan who died eighteen months after he bought it. For a long time it was parked in a barn. His sons came by a couple of times a year, drove it, and took it to the service station. Once when they had it out, a friend of ours saw it and bought it from them. He drove it for seven or eight years, then we bought it from him. It has only 18,000 miles. It still smells like new inside.

"The dark green car is the four-door version of the 1954 Loewy design."

"It has an interesting sticker in the rear window."

"Yes, it says, 'We'd rather fix than switch.'"

"This is a '63 Avanti [CENTER, LEFT], the first year Studebaker made the Avanti.

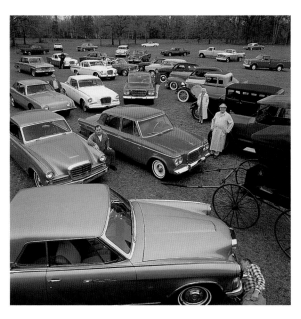

It was their top-of-the-line car and designed to attract people into the showroom so that they could sell them a four-door sedan or something. It was high priced for its time: $3,300. These were all, I think, pretty colors.

"When we bought an '82 Avanti, my wife, Mary, was driving a BMW 635, their sporty model. I asked her, would she rather drive the Avanti or the BMW? She drove the Avanti for a few days and said she'd rather have that.

"This blue GT Hawk [IN FRONT OF THE AQUA AVANTI] is a 1963. It took a little over a year to restore. The car is exactly as it was when it was made at the factory: the same color, the same interior, the same motor, and so on. All of it has been rebuilt though, so it's basically a new car and really in better shape than it was when it was made, because we took a lot more care in everything we did.

"The bright red car is a '63 Lark. We call it Blue."

STEPHEN CADE (FOREGROUND): "If your goal is to make a show car, you're better off buying a real nice, straight car and paying more money. We bought the white 1962 GT Hawk [CENTER] and the red 1960 Lark convertible just as they sit. The Hawk had had

some paint work. The front seats had been inserted. Someone had put some cheap carpet in it at some time. Other than that it's all original. Dad 'stepped up to the pump' to buy that one. He paid a lot: $5,800. He wanted a GT Hawk to win with. What he figured was, you get one that nice, and you can do that. We'll restore that car, and it'll be an easy restoration. Most of the stainless trim on it is real nice. Most of it's ding-free. There's almost no body work to do.

"The convertible we paid $2,000 for, but in the end we'll have half as much money in the GT Hawk because it's so much better to begin with. There's ten hours' worth of body work on it, where there's a thousand hours on the convertible. And the parts that we have to buy for the convertible, we won't have to buy for the Hawk."

ROBERT CADE: "Nero fiddled while Rome burned. Cade fiddles while Studebakers rust." [The fiddle is a Johann Carel Klotz, made in 1774.]

STEPHEN CADE: "One of the nice things about the parts cars is, when we're building a car and we forget how something goes or we lose a clip or a nut or a bolt, we go to the parts cars and get it. Maybe we're working on a gauge cluster, and ours doesn't look too good. We'll take pieces from each of those clusters on the parts cars and make one nice one.

"I buy all the parts cars I can. Last year we probably bought a dozen. Most of them are nonrunning cars. We tow almost all of them here. Some of them have gotten to where they're not worth having anymore, but we still keep them. They sit out here. We use parts off them; there's always more. We sell a few parts too." ●

Arlan Coffman

Wine show entrepreneur

he humble toy building block: we would never have guessed its pedagogical significance had we not read Barbara and Arlan Coffman's essay on construction toys in Home Sweet Home: American Domestic Vernacular Architecture.* *The eighteenth-century English philosopher John Locke propounded the notion that learning could be pleasurable and popularized alphabet blocks for children at a time when the purchase of manufactured toys, let alone educational toys, was exceedingly unusual. The Industrial Revolution, the mass production of toys, and the burgeoning concept of instructional play developed simultaneously in the nineteenth century. Children left to their own devices soon demonstrated that alphabet blocks were for building, and construction toys were born.*

The Coffmans described architectural construction toys as

the kind that children put together out of various pieces in order to make a miniature building, a toy village, some form of playhouse, or an engineering structure (such as a bridge or Ferris wheel), guided by a set of instructions or a teacher or solely by their imaginations. Unlike toys that are made solely for amusement, construction toys are designed to allow children to learn about the world and to develop their

26

*The catalogue for a series of exhibitions organized by the Craft and Folk Art Museum, Los Angeles, in 1982.

personalities as they play. The importance of these toys, even though the child might not see it at the time, is the process of putting them together rather than any final product that may result.

We first encountered Arlan Coffman in an advertisement that runs monthly in Maine Antique Digest. *A headline over a Milton Bradley sales catalogue (1881–82) illustration of a set that replicates Washington's Mount Vernon, reads, "Architectural Construction Toys Wanted: Erector, Meccano, Blocks, Villages, The Unusual."*

"Building blocks were always educational toys, even the very earliest sets, which were villages. Parents then were still concerned about how a toy would affect children. If they were going to give them a toy, it should be something that would teach them about life: if something falls down, you can build it up again. A lot of these toys have aphorisms in just such terms printed on them.

"I came to collecting through the back door. Because my wife, Barbara, was in architecture school, because of my helping her out—I was an English major—with term papers on different architects, my eye for building toys got sharpened before I realized it. We ended up with maybe a dozen sets when the Craft and Folk Art Museum came to us in 1981 and said, 'We hear you have building toys.' We said, 'Sure, no problem,' but when it came close to having the exhibition, I got scared. All the other lenders had tremendous exhibits, and we had only twelve toys. That's when my collecting became serious.

"I read and learned and came to appreciate the historical aspects of building toys. They're a part of our heritage that has gone by the wayside. Because I came in to salvage these items, to save them for posterity, I have an inclination toward them that is different from just trying to collect what I think is going to be popular or valuable."

"That imposes a certain responsibility on you."

"I feel on the one hand that the collection is wonderful the way it is. It shows the diversity and character of the building toys that were produced throughout history, and if I didn't buy another set, that would do it. At the same time I feel obligated. If there's something out there that's just going to go to a doll collector or maybe get tossed, I can't deny it. It belongs with the other toys. It's sort of ironical, because I don't feel that I want to amass this great collection of objects, but somehow it's there.

"Take Ohio Art, the manufacturer of a set called Zaks. They were really competing with Lego, and in a lot of ways Zaks was as good, maybe better. Then one day last summer I got a phone call from a woman there. 'I understand that you're the'—I forget how she put it—'keeper of the keys when it comes to construction sets. Because we're no longer making these, I'm sending you a copy of everything we have before we let them all go,' and she sent me one of every building set that Ohio Art had made.

When I was a kid, I played with Tinker Toys. I played with Lincoln Logs. We weren't very wealthy, and I always looked at Erector as something the kids down the block who had everything got for Christmas. I would go over there after school and try to play with it, but I could tell that this guy was engineering oriented or he had gotten that way by playing with Erector. It really was not my forte.

"In 1929 A. C. Gilbert manufactured the biggest Erector set he'd ever made, but he wanted you to buy other things from him too, so he made a separate set with an engine in it, another set that built a tender, and then a set with an engine and a tender. Then he made a set that built a zeppelin. In 1931 he made the killer set of all killer sets, which included the engine and the tender and the zeppelin. Everything is in here that you could possibly imagine, so it's one of the rarest Erector sets ever made.

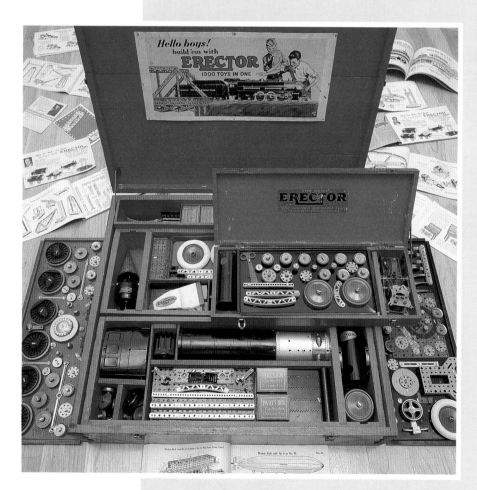

"I have a very, very comprehensive collection, not just blocks, but anything that you put together and make something architectural. It can be a landscape—we have landscape architecture—or it can be a village. I purposely do not have every set made by every manufacturer, but I have the unusual sets, so that even people who collect only, say, Erector sets, do not have the ones I have.

"Most of it has come from friends. I belong to Antique Toy Collectors of America. Members will write me once in a while saying, 'I know a dealer who has this' or 'a friend of mine has that.' The advertising keeps my name out there not only among people who may have something rare in their attics but also among dealers who deal in things besides antique toys who may run across something that will apply to me but not to their other clients.

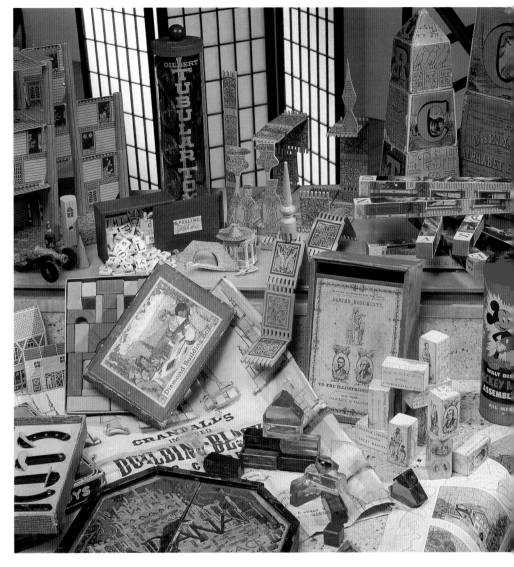

"In a normal week I get maybe four or five letters. Most of what they have to offer are things I already have, but every once in a while something pops up that's unusual. And it doesn't have to be expensive to be unusual. It doesn't have to be big."

"At the turn of the century, when kids got maybe two or three toys a year, that toy meant everything, and they were darned sure they were not going to lose a piece out of it. They put them back in a box carefully, and that's why the earlier toys are easier to find complete than the later toys."

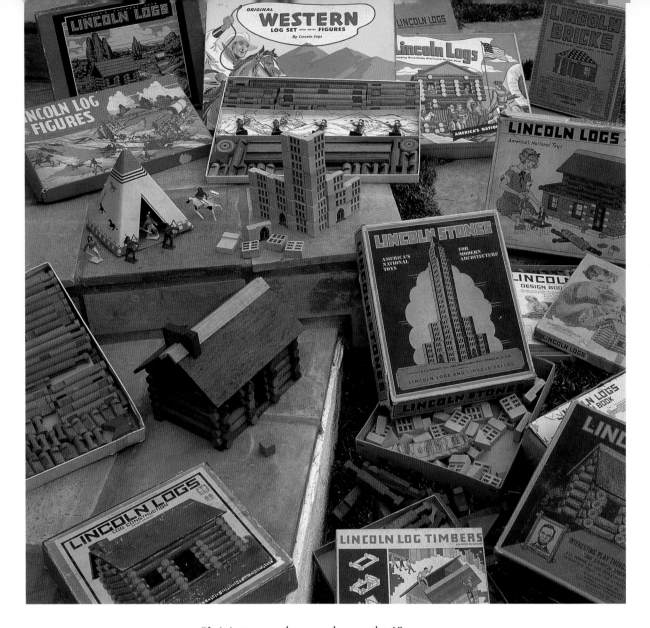

"Is it important that a toy be complete?"

"There are people that collect Erector sets who in their ads say, 'Complete. Mint condition only. Will pay top price.' I don't do that, because to me, first of all, it limits what I'm going to get. And second, there are some sets that are really incredible because they've been played with. Kids have written their thoughts on the blocks. If they had never been played with, you wouldn't have that.

"A construction toy was like ten toys in one because you could do all kinds of things with it. There are some sets where you can make a specific building only in a specific way, but those are not too common. The majority of building sets were meant to do a variety of things."

"You can't build anything art deco with Lincoln Logs."

"You want to bet?" ●

Structator built sets for the kid who was four years old, five years old, with parts they could manipulate. By the time they got to twelve, fourteen, they could do this tremendous construction."

"Fourteen? This kid would have to be forty-eight."

"Or have help. By the time you got to the large set by any manufacturer, it definitely took an adult's presence. But if you think of a kid at home from school—a whole week of rain or whatever—and he's there to do something step by step by step. It might have happened. In fact, I'm sure it did.

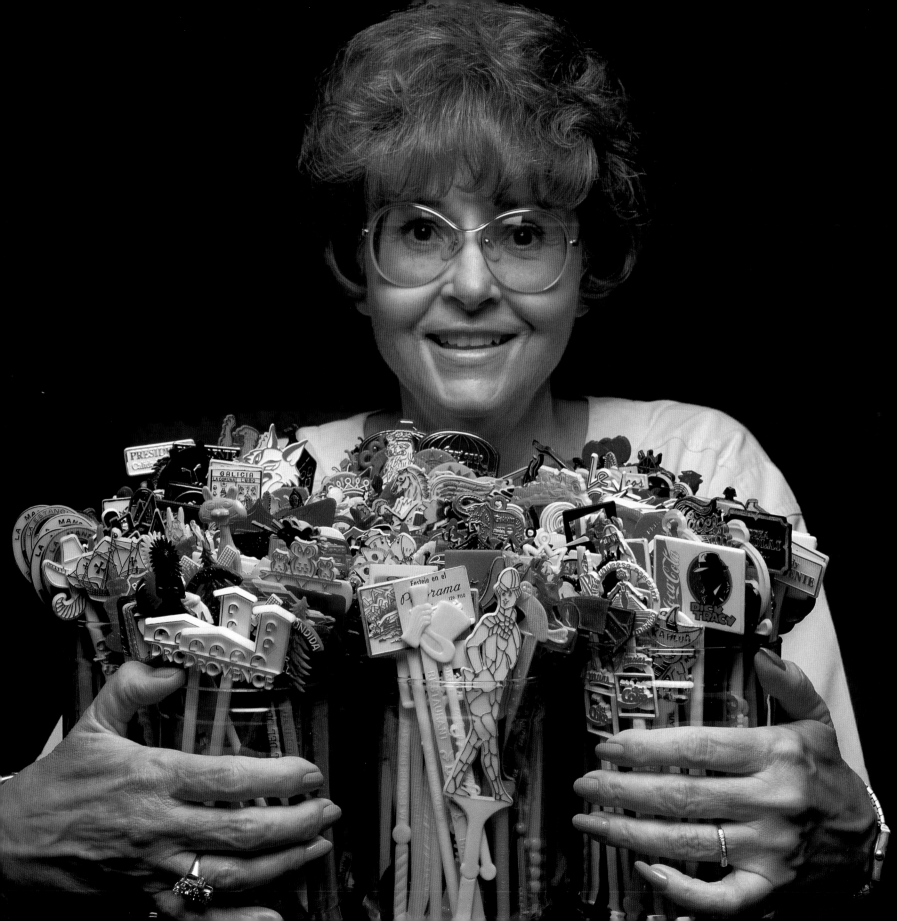

Norma Hazelton

Homemaker and mother of three

ollectors of postcards have deltiology *as a $10 word for their fancy, and* philately, *the collecting of stamps, is assertively unpronounceable. Collectors of swizzle sticks have no such distinction, but a visit with Norma and Ron Hazelton suggests that the "archaeology of gastronomy" is a not inappropriate candidate. Who but an archaeologist travels to the remotest villages to rise before dawn on a Sunday morning and sift the middens of hotels and bars for the detritus of the previous night's revelry? With subsidiary collections of napkins, menus, glasses, plates, and matchbooks— "Matches a lot of times have the same logos as my swizzle sticks; that's how I find out where some of them are from"—Norma is the archaeologist, but it's evident from what they say that Ron is fully devoted to the endeavor too.*

"I started collecting when Ronnie and I got married, thirty-six years ago. I picked up a few sticks in New Orleans when we were down there on our honeymoon. Then traveling West [from Omaha], we went to Las Vegas. We had breakfast one morning at the Flamingo, and sitting at the next table was Joe Louis. People came by and asked for his autograph. He was so gracious; I was so impressed. The poor guy never got to finish his breakfast. Now, the Flamingo is a real common stick, especially the pink one, but because Joe Louis was sitting next to me, I've kept it.

33

"That's how it started: souvenirs of our travels. I only collected a stick if I had been there. I never knew anybody else collected them. Then about 1971—I probably had a shoebox full at that time—a member of our antique bottle club said, 'Norma, you know what I'm going to start collecting? Swizzle sticks.' I said, 'I collect them,' and he said, 'Do you want to trade?'"

RON: "About 80 percent of what she's got she got by trading."

NORMA: "Or even more. We take the motor home and travel. We've gone to Canada, all across the United States, all the way down to Florida. We go to the houses of people who collect, and we trade back and forth. I take my duplicates in the motor home, and they have theirs, and we trade. I love seeing other people's collections. Then I know what to look for, what to drool for.

"I love colors, and I like the sticks for the way they look, but what I really like is knowing where they're from. Like, here it starts with Alabama [TOP ROW, LEFT] and goes through to Wyoming [THIRD ROW, RIGHT]. Of the states, the best ones you're going to find are from Florida [TOP ROW, FROM RIGHT OF CENTER] and Illinois [SECOND ROW, FOURTH FROM LEFT], and the greatest number come from Nevada. Nevada's so big I had to put it down here [BOTTOM ROW]. You can see everything's just jammed in, and I'm overflowing onto the floor.

"Now, up above I have advertising, and this is booze down below. These are airlines over here, all airlines. These are air force bases, and that whole glass over there is Disneyworld.

"You know who this is? Jackie Gleason. 'And away we go!'"

RON: "She's got Rocky Marciano and Jack Dempsey's. Stan Musial and Johnny Bench have swizzle sticks too. Here's the Oscar, but it's from Florida. It says, 'Hollywood East.' We've got Reagan and presidential inaugurations too, and here's Jimmy Carter [SECOND ROW, IN SECOND GLASS FROM LEFT]."

NORMA: "I have railroads [BOTTOM ROW, RIGHT OF CENTER], New York World's Fair, ship lines, and thermometers, which I don't really like. (I collect the straight ones, but I keep them in three huge boxes in the garage.) This is Canada—that top shelf—and that second shelf down there is all Mexico. They made big, fancy sticks just like Canada. Here's one from Canada that says, 'Give us a ring for any engagement,' and you can put that on your finger and break it off, and then you have a ring, but I hope nobody breaks them off.

"These are my specials. I just really like these, so I keep them separate. See the Marlboro Man? Here's Blondie—my toe on her is broken—and here's Dagwood. The collectors all look for Blondie and Dagwood. This is Dagwood, just his head; I have a lot of colors in this one.

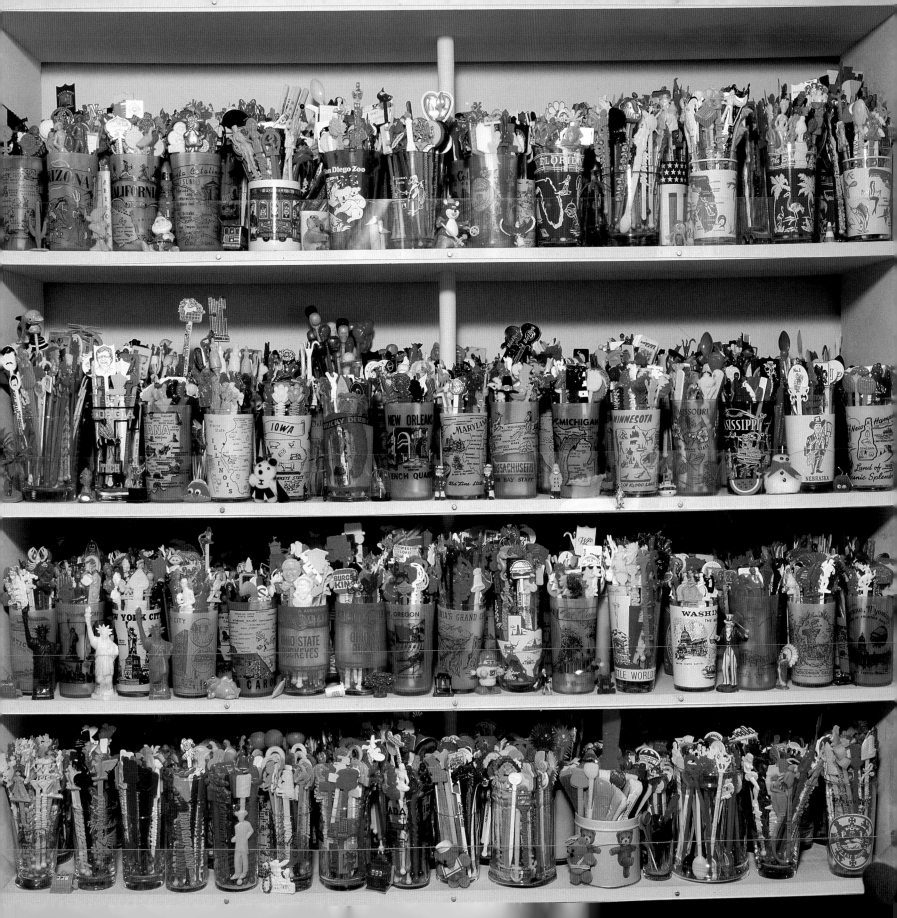

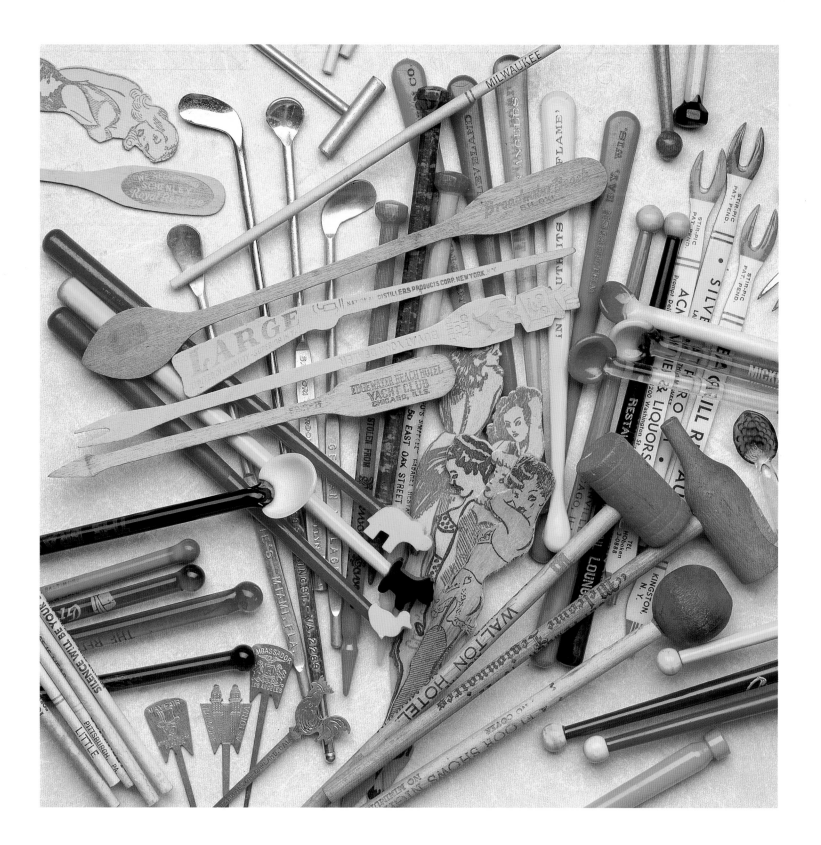

They claim that back in the 1800s a lady in an inn somewhere started mixing drinks. She used a rooster's tail feather as a stirrer, and that's how cocktails got started. I'm not sure if that's true or not. One person says it was in the West Indies, and another person says it was in Bermuda where they made a rum drink and called it a rum swizzle. They used a stick— I forget what kind of wood—to stir the drink. A lot of people think that's where *swizzle stick* came from. Everybody has a different idea about when swizzle sticks started. I know that Prohibition was over in 1933, and the flat wooden ones were started in 1934. They had them during the war too, 'cause I have a lot with 'V for Victory' on them. And they were still making wood right up into the '50s.

"In glass I have amber, blue, clear, and green, red and purple and blown glass with paper inside. Then, of course, I have Bakelite swizzle sticks, rolled paper, paper in celluloid, here's a metal one, and we have wooden knockers too.

NORMA: We can look at a stick and tell you if it was made by Beacon's. Beacon's was always a really nice stick."

RON: "Or Zoo-Pic or Spir-it or Royer's."

NORMA: "This stick from the Chez Paree in Montreal was made by Payge; they were a Canadian manufacturer."

RON: "You know what's fun? To go to a swizzle stick factory, and in the storeroom they've got samples of each kind. You walk in, and you go mad. You go, 'I want one of everything.'

"We did very well at Royer's. We figured they'd be about a nickel apiece and walked out with two shopping bags full. Norma asked, 'Will you take traveler's cheques?' and the man said, 'No, just enjoy them.'

"And here is probably one of my all-time favorites. This is from the Chi Chi in Palm Springs. It's Tahitian, and it's from a real famous picture. This is the only one I've ever seen. There might be other people who have it, but I've never seen it in their collections.

"My specials include Annapolis and the Centennial Club in Texas, and this one's a cigar. Why they made one for a cigar, I don't know. They also made a swizzle stick for beer.

"Here are trains. This one looks like it's coming 'round the bend. I'm the only one I know so far who has the D & H, the Delaware & Hanover railroad.

"I'm trying to get all the glass ones from the states, and that's really hard to do because some states were dry. So I don't have Hawaii, I don't have Kansas, I don't have Mississippi, which I should have. There should be a Mississippi. There should be a North Carolina. I don't have an Oregon or a Utah in glass either."

RON: "Remember the picture *A Night to Remember*? They've got one with the *Titanic*, and it's going down. She can't get that one. Somehow she can't get that darned stick."

"Given that swizzle sticks were designed by the thousands and molded sometimes in dozens of colors, quantity seems an inevitable concomitant of collecting."

NORMA: "Some people count. Some people say, 'Oh, I've got 30,000,' and brag about it, but I don't count my sticks. Now, there's a man in New York who claims to be the biggest collector. When I go to his place, I do see some that I don't have, but I also see some that he doesn't have. There're five that I've been to, five really big collectors in the United States and Canada, and I'm right up there with the five.

"But like everything else it's quality that counts. I've gone to people's houses that have had like a thousand sticks, and maybe five hundred of them I don't have, and I would love to. So it's not quantity at all; it's quality or it's places."

"I was tempted to buy my first three swizzle sticks at a flea market, but they were fifteen dollars apiece, and I wasn't sure of the going rate."

RON: "People are crazy on prices. In order to get a stick like this Union Pacific Domeliner, they'll want two or three dollars, and it's not worth it."

NORMA: "We don't buy them. We pass them up. Everybody in the club, the International Swizzle Stick Collectors Association, says, 'Don't buy them. They're just a throwaway. They should not be that price.'"

RON: "Someone had those Domeliners for ten dollars apiece at the Long Beach flea market, and actually a dollar is about the going price, two dollars. A metal one you shouldn't pay more than two or three dollars. And glass, I don't pay more than two. She'll pay four or five on a good one. I did pay twenty dollars for a Southern Pacific one time, glass—either that or a Santa Fe—it was so unusual.

"Kovel wants to put a book out on swizzle sticks. Of course, that'll kill the business. It'll make the prices sky high like antiques and everything else went." ●

Ed Ruby

Businessman

Toy soldiers

riting in 1987, connoisseur James Opie (Collecting Toy Soldiers) *was unequivocal in his estimation of Ed Ruby's collection of military figures made by Britains, the most prominent of English manufacturers. He called it "the finest I have ever seen or heard about."*

Ed started collecting with the residue of a stock of Britains that he was selling retail in his [hardware] store in Chicago. As the core of his collection of Britains figures, in all their intriguing versions and mellow early paintings, has grown, he has gradually divested himself of all distractions…and concentrated on showing the diversity and interest of Britains within a single, fully glass-shelved room.

Although Opie had noted that Ruby had few acquisitions yet to make, with the passage of just a handful of years has come a second room.

"A collector is a person who gets many things he resents getting, but he has to get them to complete his collection. It's no different from an alcoholic or a person on drugs, except that it doesn't harm your health. It's more of a compulsion, I think, than an addiction, because if you get tired of it for a while, you can drop it altogether, but when

40

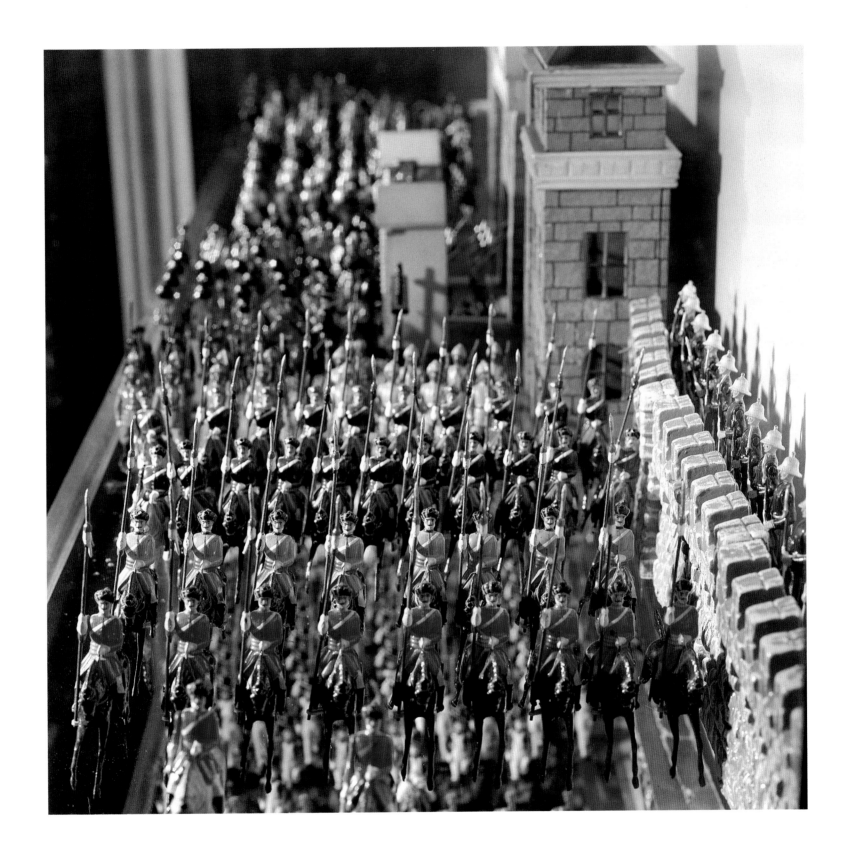

you get into it, it's like getting on a high. The collector's always got to have something coming.

"I differentiate between collecting and accumulating. Those items that you collect, you want everything that they ever made, every variety. That's what collecting is. Accumulating is just getting things that you like that are nice.

"Most toys are collected on the basis of nostalgia. You've got to consider the fact that Britains discontinued making what I collect in 1966. I was fortunate enough to be doing this at the very, very, very beginning. I was at the first auction, the first time they had an auction of toy soldiers in London. That was in 1969, and I wish I had spent more.

"Although I wish I had spent more, I did do it right. I always bought the Mona Lisas. If you don't have a rare item, if all the items that you have everybody else has, when it comes time to dispose of your collection, nobody is going to pay you.

"If this item books at $180 and everybody has it, they're only going to pay you a fraction of that. But if you have the rarest of the rare, you can say, 'What? You want my rarest of the rare? You're going to pay me what they're worth, the fair value, and it's going to be your job to get rid of the rest.'

"You collect stamps? OK, everybody's got from the half-cent Columbian up to the fifty pence. Go, try to get what they're worth. But if you have the one, two, and five dollar on the Columbian, they'll pay you what those are worth. That's the difference between collecting and accumulating.

"I got started early, and I understood how to collect. My father and my uncle, my uncle especially, didn't collect; he was an accumulator. I learned from him not to accumulate. When you accumulate, there is no value to it."

"What makes Britains more appealing than other manufacturers was their sculpting ability. Others would do some that were far better, but Britains's overall average was more consistent.

"Britains kept everything up-to-date. When the war in the Balkans came before the First World War, they started making the soldiers of the Balkans; they made the Montenegrans, the Bulgarians. When uniforms changed, they would change the uniforms. When the British went from a half boot to long pants, they changed the soldiers from a half boot to long pants.

"Britains also did one thing that's very important to collectors: once they gave a set of soldiers a number, that was that set's number even when they changed uniforms. If I want to talk to somebody or write, I can say, "I want set no. 1658," and anybody can look it up. None of the other manufacturers, or very, very few, gave them numbers and kept with that number. No. 1 was the Life Guards in 1893. You would have versions— Life Guards first version, second version, third version, fourth version—but it was still no. 1.

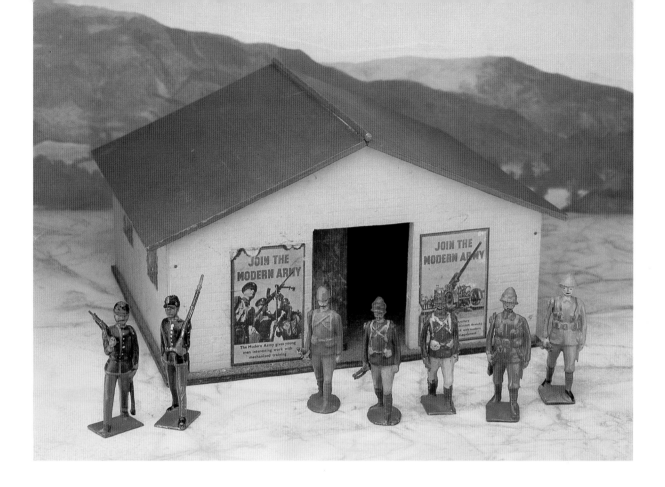

"You could go in some sets up to eight versions. You see these two Austrians Foot Guards? Same set, only one's marching angular on the base [LEFT, a figure from 1912], and the other one's marching straight on the base [SECOND FROM LEFT, a figure from 1922].

"These are the Dublin Fusiliers. You see, they're on round bases with smooth helmets; that's first version [THIRD FROM LEFT, a figure from 1901]. Second version: they're still on a round base, but now they have the Woolsey helmet [1904]. Third version: now they're on a square base with a Woolsey helmet [1908]. Then fourth version: it's a totally different helmet [1916]. Then there's the last version right there: helmet again [1935]. So that's all the same set, same number, but you just saw five different versions. [The building in the background is a cavalry stable, made for Britains by another manufacturer, Hugar, in 1939.]

"There are probably not more than eight or ten people in the world, if there's that many, who can look at this collection and totally understand it, totally understand it and know what they're looking at. It's really not that easy to understand because you've got various varieties.

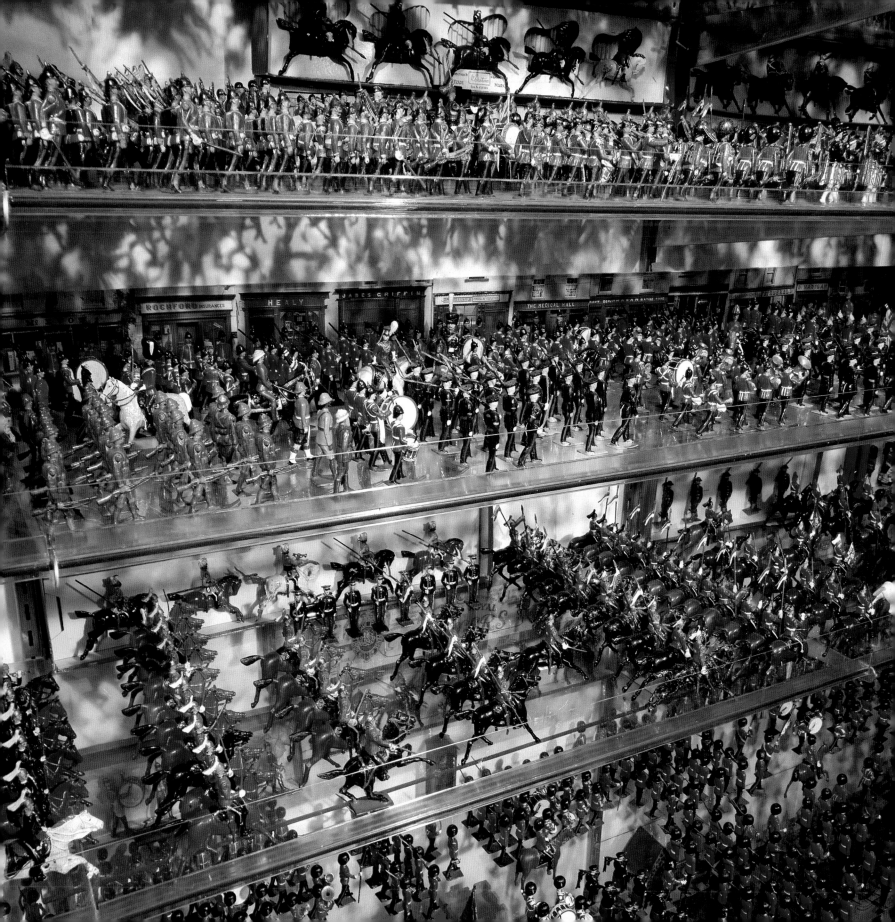

"

This room is supposed to really be the way I thought a toy store looked to me back in the late '30s. These are actually store fixtures. It's supposed to say, 'Buy me.'

"You know, when you become an adult, it's sort of embarrassing to collect toys. I had a hardware store, and I was a big dealer in HO trains, and one day one of the salesmen came in and told me about this club that was a soldier club. What they did mostly was paint the figures, but some of them collected. I just got into it from there. As a matter of fact, I was a Britains dealer the last couple of years I had my hardware store.

"These were in their day as toys considered the top of the line, very expensive. Only your top department stores carried this line because these were considered expensive toys. Well, what happened, plastics were coming in. Lead was considered toxic, although there were no known cases of anybody getting sick from Britains soldiers, but they just phased them out.

"

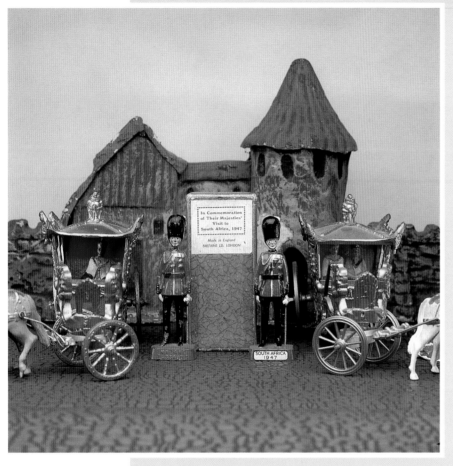

"I think the ones that I would be most fond of are the ones that have the best stories behind them. See those two sentries? The box belongs to the one on the right."

"*In commemoration of their majesties' visit to South Africa, 1947.*"

"So, that's George VI. The one on the left is the absolute identical figure except the base is different. Can you read what it says on there?"

"*Madame Tussaud's.*"

"Made for Madame Tussaud's. That's the same figure, but that's Edward VIII. I call them the brothers. Those are the only two known figures.

"Or take the coronation coach. I have several of them, but if you look inside the one on the left, you see there's only a single person sitting. That's Edward VIII. Well, Edward VIII was never crowned king—he abdicated the throne—and so they only made that figure for a very short period."

"*Which means it's very rare?*"

"Exceedingly rare.

"

"What I'm looking for is something that I've never seen before. Ninety percent of the items that I get today I didn't even know existed until they came up for sale because Britains made so many special things. They made a tremendous amount that never got into the catalogues because they made them special, and you didn't have to buy very many to get them. There was a store down in the Bahamas, a drugstore; they made the Bahamas police band and the Bahamas police only for that store [late 1950s–early 1960s], you see. I've got probably everything they made that ever went into any of the catalogues, but I probably don't have—I know I don't have—every variation of everything they made. I have maybe 84–86 percent of the known, listed variations of what they made in military."

"Were there ones that you had to look long and hard for?"

"Long and hard."

"How did you feel once the long search was over?"

"I was just happy there were other things to search for."

[The labeled figures in the foreground are Britains paint masters. The gray figures are mold masters.] ●

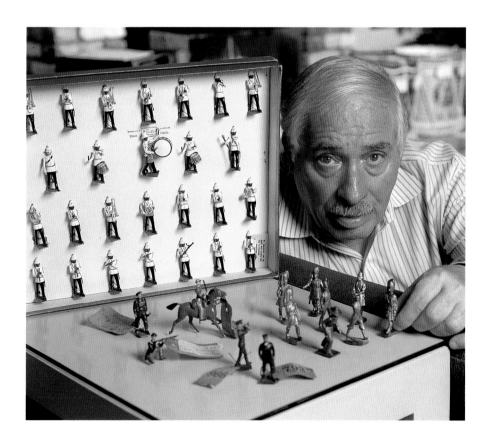

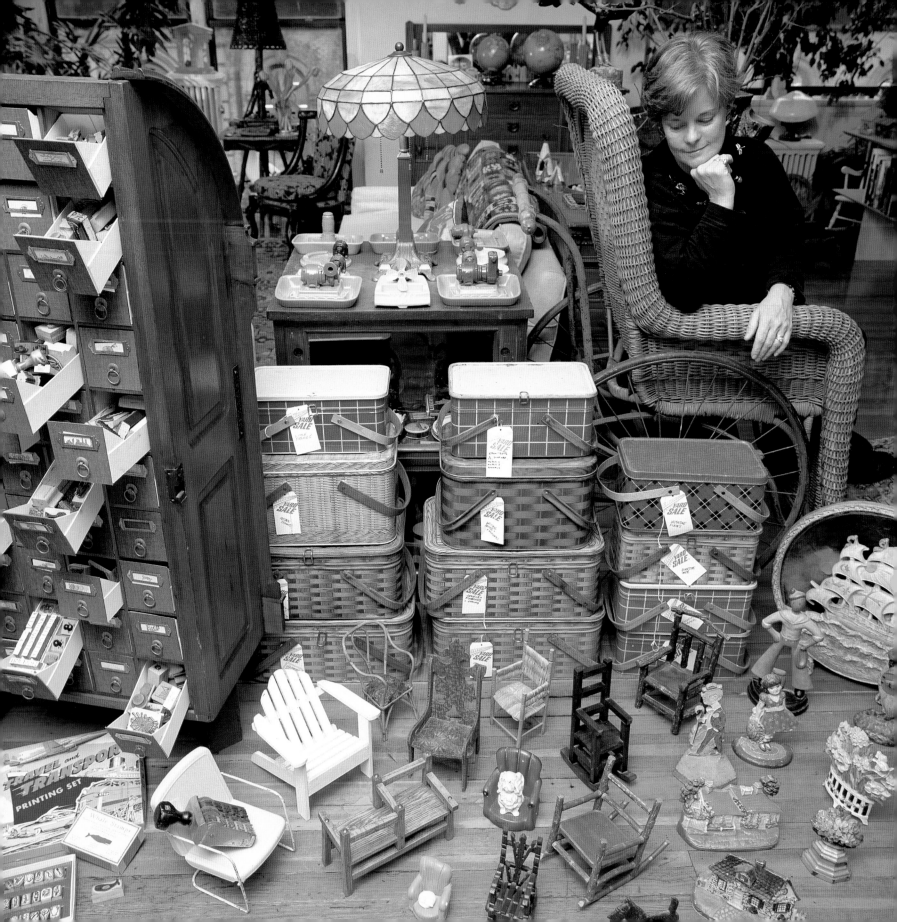

Dorothy Twining Globus

Former Cooper-Hewitt Museum curator

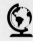

Everything

*Peter Carlsen,
"If It Moves,
Collect It,"
New York,
May 29, 1978,
pp. 44–45.*

A s long ago as 1978 New York magazine acknowledged the awesome proclivity of Stephen and Dorothy Twining Globus to collect: "Anyone can collect something; it's hard to collect everything." Understandably there are those who find a visit to the Globus loft a bit like wandering into the business end of a kaleidoscope, but a moment's reflection reveals this is no chaotic miscellany. Dorothy Twining Globus, the chief collector—"Stephen's got a visual affinity for it, but I'm really the major packrat here; it's my obsession"—has a remarkable curatorial eye that can abstract any object from the context in which she encounters it and see it as the embodiment of a theme, a color, a shape, a design, the exemplar of a process of manufacture. This taxonomic turn of mind with its references and cross-references permits the casting of an ever-more encompassing net, into which items of an astonishing diversity are drawn.*

"After all the years at the Cooper-Hewitt it's clear to me that there are people out there collecting almost everything. I'm interested in collections of things that other people don't care about. You find the most amazing variations even with the most mundane of objects. And it's not necessarily old things. Sometimes it's new things. I like mixing old and new of the same kind of product."

49

"Have many of these neglected categories been transformed into things other people do collect?"

"My biggest blow there came when Ricco-Maresca Gallery did an exhibition of coat hangers a couple of years ago. It was a beautiful show—the hangers were great—but they wanted $60,000 for 500 hangers. There was a rumor that Armani bought them. 'Oh, damn,' I thought, 'there goes the market.' I guess it really didn't make that big a splash in the greater scheme of things, but prices did go up."

"How does one of these collections start: the globes, for instance?"

"Well, our name is Globus. We'd been collecting other things and realized, 'Gosh, we've never collected globes.' So all of a sudden we were. It's all serendipity really. I was at the Pier [antique] Show [along the Hudson River in Manhattan] three years ago with a very serious collecting friend, and we went past a booth that had all these watering cans. It was unusual to find that many at one time, and they just spoke to me. The dealer's name was Mr. Zink. I mean, it was too good. I said, 'Wow, don't those look great all together?' and my friend said, 'C'mon, Dorothy, get 'em.' So we walked out with twelve watering cans, and everybody thought we were absolutely out of our minds."

"In that case you acquired a complete collection."

"No, no, it was latent. I already had two, and still they're the best ones."

"When a dozen or two items show the diversity within a category, is a collection complete and you move on?"

"I always pick up things. I go to another antique store, and I see another flower frog."

"But you're not pursuing the history of the flower frog in all its manifestations?"

"No, I'm not exhaustive. I would much rather follow different tangents all the time. These are just miscellaneous great things. This is just an accumulation. Maybe we should walk around and look at stuff.

"I love little buildings. That's really one of my passions.

"Train tunnels are something that I find very appealing, and Christmas tree buildings. You put little electric lights in the back, and the windows glow. Then I got into collecting little trees.

"I find intriguing things that people made themselves pre-television, things they put a lot of effort into, often to have them disbursed by their less-sensitive progeny. For example, I have a collection of pyrographic (wood-burning) art. I have tie-racks, boxes, bowls, plaques, match holders. Some are prestamped kits; they are obviously much less appealing than the ones made by hand.

"I love boxes. I'm obsessed with boxes. I've had people come in here and say, 'There's a Virgo in this house,' because Virgos like to put things in boxes and categorize them."

"Was there very much movement between your collections and the Cooper-Hewitt exhibitions?"

"Oh, sure. I used my stuff all the time. About twenty of my maps were in the map show (1992), and I lent quite a few pieces to the button show (1982). When we did our show *Bon Voyage: Designed for Travel* (1986), needless to say we all knew that part of the Globus folding hanger collection would go into it.

"I don't want to impose my collections on people. Some people come in here and want to walk right out the door. For soulmates, however, we can get off on things and spend hours looking at this stuff. It brings me great joy to sit here and rediscover things.

"Most of my furniture I consider part of the collection. I have three dental cabinets. I have typecase drawers. I have a great Wooton desk. I store things in these picnic baskets. I like trompe l'oeil: in this case tin painted to look like a basket. Also I like them because they're still something you can get for under $15.

"The little chairs I collect because I can't collect big chairs.

"Doorstops...

"Old Dutch Cleanser labels, enameled signs, and print ads...

"Chickens plus a couple of ducks and a few roosters...

"Fences...

"Columns...

"Cactus...

"Obviously I can't keep it all out. I got the Wooton desk because of my rubber stamp collection. It was the desk that led me seriously into stationery products.

"Paper clips...

"Thumb tacks...

"Staplers...

"String dispensers...

"Pen holders...

"I'm also collecting modern stationery things, because there are fabulous pens and markers being designed now. I often buy markers to collect, but I use them first.

"Rubber stamp pads and rubber stamp holders...

"Paperweights...

"Pencils and pencil sharpeners and erasers. My son, Sam, is an accumulator like me. He's the designated eraser collector in the family. He's been written up in the *New York Times*.

"I have a very strong affinity for Dennison's gummed labels. Everything now is self-adhesive. I have books Dennison published on making things with their paper products, like crepe paper flowers. The craziest one of all was making sealing wax art."

"Do you have a way of distinguishing a mere possession from a collection?"

"My hairbrush is a possession. Bug jewelry is an obsession."

"Do you think in terms of the individual object when you make a purchase, or do you think in terms of the collection?"

"Certain things I just have to have, and other things it makes sense to add. I don't really collect frogs, for example, but I have a couple of good ones. Theme is one of the easiest ways to add to the various collections, and themes cross the categories of objects. I have fish in my rubber stamps, for instance, and I make cards with fish, and I have fish jewelry."

"When is a particular collection complete?"

"I don't think it's ever over for me. It may go dormant. I haven't really arranged a lot of stuff in these type drawers for years, but if I pick up some beads, which I do from time to time, I may put them in here.

"At first the need for the typecase was driven by my bead collection, which was in fifteen boxes. You see, things are sorted by size. Then the typecase began to drive the collection. The bugs and fish are now in one drawer, but they ought to be broken down. I definitely have enough for a drawer of bugs and a drawer of fish, but that means taking all the drawers out and realphabetizing them, and I just haven't gotten around to it. I love making Easter eggs, and every year I do an 'eggs-hibit' at Eastertime. Most of these are ones I've made with my children and my friends.

"After the *New York* magazine article, someone contacted me and said, 'I have my grandfather's cigar band collection,' and it was like another little treasure. I feel an obligation to take care of these unwanted collections. 'Call me! You know, it's very important.' A friend gave me his Boy Scout cards from a ten-year span. He said, 'I have saved these all my life. I don't know what to do with them. You'll give them a good home.' I get a little choked up when someone does that."

"Can you identify a time when the collecting started?"

"As a child I traveled around a lot and didn't accumulate much stuff. It was really when I started going out with my husband that it began. Having a house in Bucks County, Pennsylvania, for years and going to auctions there, that's when the volume increased exponentially. Since we had the kids, we've slowed down, but it's still a steady accumulation.

"Incidental funky ashtrays...

"Die-cut valentines...

"Cigarette cards...

"Matchbox labels…

"Business cards: graphics are a strong motivating factor, I think, in a lot of the stuff…

"Miscellaneous carded items: snaps, hooks, buttons…

"Plastic belt buckles…

"Curtain tie-backs: glorified thumbtacks for your kitchen curtains…

"Clothespins….

"Sugar packets: I saw one that had the Mona Lisa on it that said, 'Painted by da Vinci. Printed by Domino.' It was the funniest thing. Now I have Pinky and Blue Boy…

"Stick furniture…

"Little kitchen stuff…

"Twenty-five scrapbooks that someone else made. I have my own scrapbooks too, and I do photo albums for my children, but I'm always two years behind because I just can't glue square pictures into albums. I have to cut them all up and make collages."

"It looks like you embrace almost anything and fearlessly start new collections."

"Not everything. I have moved on to mental collections."

"What do you mean by mental collections?"

"Things that I wouldn't mind collecting. After the watering cans I found a very nice ornamental lawn sprinkler: a duck with the water coming out of its beak. Lawn sprinklers are now a 'mental collection,' because I can't afford to buy them all, and I don't need them."

"Is there anything that wouldn't fit?"

"My standard line is, I do not collect Avon bottles.

"My daughter has unfortunately succumbed to trolls, which turn my stomach, but at least I've deprogrammed her for Barbie dolls, which I've always hated. One day I said, 'OK, Doro, you don't need another damned troll,' and she said, 'Mummy, you collect what you want. You add to your collections. I'm just adding to my collection. So respect me for my collection.' It was like, 'Whoa!' It totally shut me up." ●

Meredith Brody

Writer

ot through any fear of impropriety, lack of curiosity, or well-bred reserve, we never mentioned price unless the collector mentioned it first. In most cases the subject simply didn't come up, though many collectors rued in a general way the escalation they had witnessed. Meredith Brody collects Bakelite baubles. There was a time when you couldn't give those things away. That was B.W.: Before Warhol. Prices on Bakelite have risen precipitously since the posthumous auction of 1988. This presents a certain challenge but not an outright impediment if you know a thing or two about a bargain.

"I started…I don't even know how…probably the same way I started collecting pottery: I bought for color and for price, and the price was just as important, because my first rule was, I didn't buy anything that was over five dollars, which makes things highly limited. My limit is now fifteen."

"That's good, you can set a limit."

"My income sets a limit."

"Do you ever break through that?"

"My friend Jeff Weinstein talked me into buying this [an amber Bakelite bracelet with an applied black Bakelite bird in flight]. He found this himself, called me up, described it

57

to me, and told me it was ninety bucks, and I said, 'Absolutely not.' And he said, 'What if I split it with you?' When a friend makes an offer like that, you say OK.

"Other than that I still haven't gone beyond my limit. In some ways I should because there are lots of things here I got for fifty cents or a dollar, and you sort of think, 'If my limit had been higher in the beginning, I could have gotten more glamorous things.' I mean, you know what I mean, things that are carved. I'm not so nuts about the ones that are carved actually, but I do like the ones with dots on them like Warhol had. I'm still kicking myself over two that I didn't buy for a hundred dollars each which today are worth, like, four hundred dollars each. But this goes on with collecting all the time. People often say in the beginning you should spend the most you possibly can, because things won't lose their value, and they're usually right.

"When I seriously started buying was probably after the Warhol auction [April 1988]. I went with Anne Friedberg, and we had a plan: we would go in together on a bagful of Bakelite, keep some of it for ourselves, and sell some of it to other people, but before we could even get our paddle up—because it had this imprimatur—the price would be up to, like, thousands of dollars.

"I guess I'm what's called in the collections field a 'bottom fisher.' Unfortunately I don't have a lot of knock-your-eye-out pieces unless I run across somebody who doesn't know what he has."

"Can you get a better bargain from a nonspecialist than a specialist?"

"Oh, absolutely. You know that yourself. Sometimes you see somebody who has just one piece, and he's looked it up in Kovel, where it says twenty bucks, and he marks it twenty-five just for the hell of it. You'll never buy it from him. More often if he doesn't see it very often, he doesn't care, and he marks it a couple of bucks. He just wants to turn it over, because he spent a quarter for it, obviously."

"Why Bakelite?"

"I like the texture. I love the colors. I started buying basically greens and ambers, and then I spread out—obviously, or I wouldn't be wearing reds and blacks now. But that's just how I started.

"I wear everything. I like waking up in the morning and putting on an armful. I feel like I'm dressed. I play around with them. I decide whether these look better together with those, or I might alternate different shapes and colors till I get something that looks good.

"The other day I was wearing an armful, and my father said to my mother, 'Do you know why Meredith is wearing six bracelets? Because seven would be vulgar.'"

"An armful is six?"

"It depends. Some of the thinner ones I've gotten up to twenty on each arm."

"How do you decide on a purchase?"

"The first decision is aesthetic. When I saw this one [SECOND COLUMN OF BRACELETS, FIFTH FROM THE TOP], I thought, 'It's not striped, but it would look great with striped

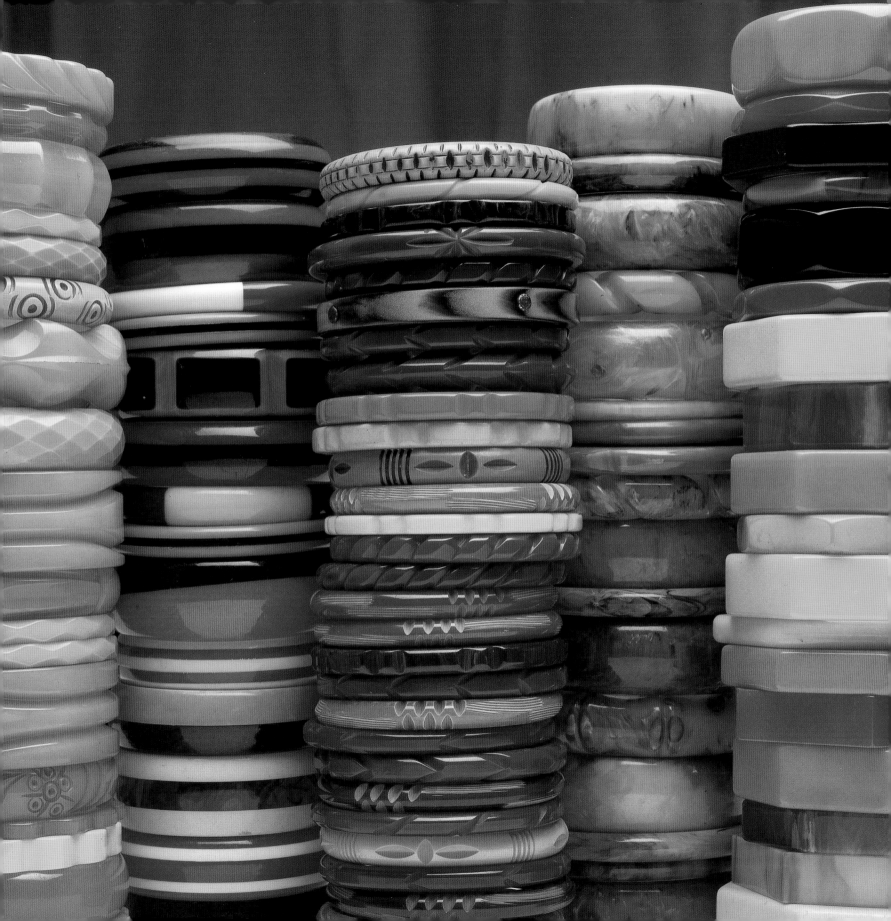

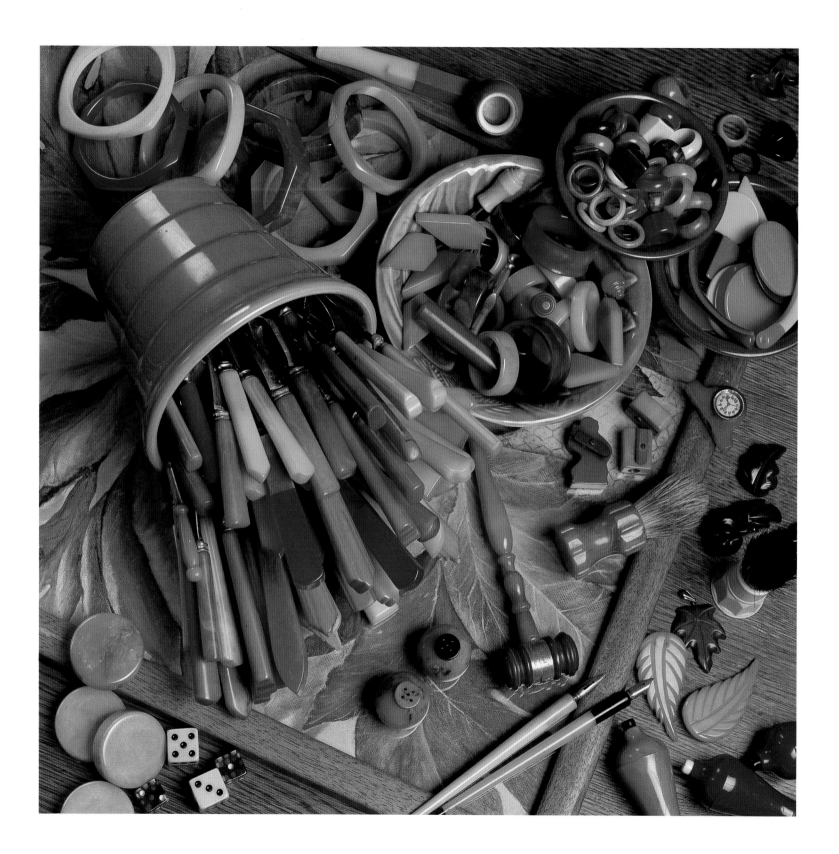

bracelets.' I had Bill Stern with me, and the dealer said, 'Twenty bucks,' and I started to walk away. Then she said, 'Oh, OK, fifteen,' and I was still not going to get it, but Bill picked it up and said, 'I really think this one is special, Meredith.' So I bought it. I mean, I sometimes need a push because I've got so many now that I feel a little guilty about getting more, especially as I can only wear so many at any one time. That's partly why I've expanded into rings and necklaces. Lately I've started buying necklaces, because you can still get them cheaper than bracelets. Oh, I didn't show you my earrings."

"Obviously if you look around at all the chatchkas that are everywhere in every room, it doesn't necessarily have to be Bakelite jewelry. There's Bakelite everywhere you look."

Bakelite gavels, Bakelite salt and peppers, Bakelite backgammon pips, Bakelite shaving brushes, Bakelite drawer pulls, Bakelite flatware, Bakelite cigar and cigarette holders, Bakelite pipes, Bakelite pencil sharpeners.

"These [spherical salt and pepper shakers, TO LEFT OF GAVEL] are things that I'd seen all over in malls and antique stores, and they usually are about fifty, fifty-five, sixty a pair. They were in a mall where everything was 20 percent off, and they were in a locked case, and I thought, 'Am I going to call the girl over and have her unlock the case? I know they're going to be fifty or fifty-five. And even if they're thirty, they would be out.' So I called her over, and they were fifteen. So I grabbed them. That's what I mean by a bottom fisher.

"I like to do a little flea-marketing with a certain amount of money and come home with as much as possible. If you go to a flea market with $60, and you spend it all on one item, then your day is finished. I like to look at everything. I remember the last one I went to. I got up early, and I went, and I ran out of money, and went to my friends who run the Flying Unicorn [antique shop], and I really felt like a junkie talking to her dealer and saying, 'C'mon, c'mon, you know I'm good for it. Give me five dollars.' 'Cause if you're not in the money, you can't play anymore." ●

Bill Stern

Writer

ottery was for the patio, porcelain for the dinner table until the Big Five of California—Bauer, Gladding-McBean, Metlox, Pacific, and Vernon—and smaller manufacturers, notably Brayton Laguna and Catalina, began mass-producing and widely distributing extensive and imaginative lines of brightly colored, hand-thrown and jiggered pottery tablewares in the late 1920s.

At its height in 1948 there were more than 800 potteries operating in the state that made both dishware and decorative items. But by the '60s, after the disastrous decline of California potteries due to government-encouraged imports from Japan and…Germany…and the resumption of imports from England, relatively little "Made in California" pottery was still being produced.*

Hardly more than a decade had passed since the closing of the J. A. Bauer Pottery Company in 1962 before a strong secondary market in many California potteries was flourishing. By the late 1970s apocryphal tales of startling accumulations by collectors were rampant: the most common was the one about a lady in Bakersfield who purchased 500 Bauer cookie jars with lids intact for a pittance from a local nurseryman.

62

*Bill Stern, "Color Crazed: Exposing California's Radical Pottery Past," *LA Weekly,* October 18, 1991, p. 64.

If such tales were true, they spoke alternatively of diminishing reserves or of tantalizing possibilities.

"When every other collector of California pottery is collecting Bauer, Catalina, and Pacific, why did you turn to Vernon?"

"I didn't 'turn to' Vernon. At the time I started, I had no idea that anybody collected dishware. I had no intention of collecting dishware. I had a neighbor, a porno film star, who was moving to Texas. He lived across the courtyard and had seen Navajo rugs in my apartment. One day he said, 'I have a couple of Navajo rugs,' and I went over, but his rugs didn't interest me. Then he said, 'I have this set of dishes.' I'd never seen anything like them. I went back across the courtyard and called a friend who had furnished herself and her apartment with garage sale finds. I described the dishes to her; she had never seen anything like them either. She asked, 'How much are they?' and I told her, and she said, 'Do you like them?' I said yes, and she said, 'That's the answer.' So I went back and bought them—a service for four in the four principal colors of Vernon Early California—and brought them across the courtyard. I took some books off a shelf in a pine dresser, and I put the dishes in. Then I looked at them, and I thought I heard a voice say, 'More!'

"Shortly after I bought that first little batch, I went to somebody—I can't remember whom—and asked, 'Where will I find this stuff?' and the answer was, 'You look in used furniture stores.' There's often stuff in the furniture that dealers buy.

"There's just such a place in Glendale, so I went there and opened up a cabinet, and there were 125 to 150 pieces of Vernon, and they wanted to *give* it away. At the time I didn't know anything about anything. I didn't know there was a book on Vernon. I didn't know that other people collected. I just knew that this was a lot of pottery, and it was very cheap, so I said, 'OK,' and bought it all."

"The company called Vernon Kilns took over from a preexisting company called Poxon [China Company] in 1931. Poxon had been in Los Angeles since early in the century, producing stonewares. Then in the late 1920s they started producing finer dishware—not as fine as china—with many different kinds of decals, often very fussy. Vernon continued some of the fancy production, but they very quickly recognized the appeal of solid-color dishware, which had been introduced in California by Bauer, Pacific, and Catalina. Although Vernon was a less rustic style, it used similar bright colors, the characteristic California yellow, orange, green, and cobalt. Then the company introduced an original line of shapes that were rounded—not quite streamline, but moderne—in pastel shades as well as the earlier solid colors. Later they introduced

Ultra California, a shape that had upside-down handles, which were not only beautiful and original to Vernon but were catastrophic. There's a reason why handles are the way they are, that is, wider at the top than at the bottom, and that is so that you have someplace to put your thumb to balance the weight. When you get to large Ultra California hollowware pieces like teapots and pitchers, it's really impossible to hold them. It was a disaster.

"The artist who did most of Vernon's decorating— maybe 70 percent—was named Gale Turnbull. He also produced a lot of designs that did not go into regular production. Among them is a series called Blends [RIGHT], of which there appear to have been nineteen, although so far only about eight or nine have surfaced. Each is different, and not all are two colors.

"When I first started buying Vernon, I only bought the solid colors. What I liked principally was having stacks of colors, and periodically I would change them around. For a while there'd be stacks of blue plates with stacks of yellow on top of them and stacks of green. Then I'd alternate colors.

"Oddly enough, although I have a lot of stuff, I don't like clutter. I don't hang plates on the wall. More than I would like is behind closed doors."

"Do you see a distinction between accumulating and collecting?"

"I accumulate in the sense that it doesn't matter whether I have something. If I see a bunch of it and it's reasonably priced and it's something I like, I buy it. I saw a box of fifty-eight pieces of Ultra California at the flea market this week, and I just couldn't leave it there. So I would be more of an accumulator in that sense.

"On the collector side, I'm interested in the company, the history of the company. I'm interested in historical pieces. I buy anything that I've never seen before.

"It's important to have a good eye. I've bought things that I know are Vernon simply because of the glaze. I have a couple of pieces that are not marked, the early pieces that had paper labels, and there are very few paper labels extant. I have two, and that seems to be two more than other people have.

"I never go out shopping saying, 'I want to find X, Y, or Z.' I love finding whatever's there. If you're going to look for a specific object, you're going to be sorely disappointed. I have a cousin who's a psychotherapist, and she explained to me how this works psychologically. It's called intermittent reinforcement. If you go out every day and you find what you're looking for, you get bored. There's no thrill. If you go out, and every other time or every sixth time—there's some limit of frustration—you find something, then you've got your reward, and that's intermittent reinforcement.

"Finding these bunches of Vernon over the years, there have been periods when I've said, 'What am I doing? Why am I getting all this stuff? What am I going to do with it?' Sometimes I say, 'Forget about it. I'm not going out.' And then the next time I go out, I find something wonderful, and I say, 'Why wasn't I out here last week? I would have found something even better.'

"Now, the availability of Vernon varies depending on the part of the country you're in. In California it appears to be fairly common in flea markets because the people who sell in flea markets know that there's a market for it. You also see it in antique stores. In Missouri, with the exception of one shop I know in Kansas City, you probably won't find it in stores or flea markets, unless somebody's bringing it from his own house, because dealers don't see that there's a market for it, and dealers will not buy things that either they think there's not a market for or they're not attracted to themselves. That accounts, I believe, for the fact that in Missouri, for instance, in antique malls where there are lots of dealers I only come across unusual pieces of Vernon, what dealers think are decorative items. They do not buy the cups and saucers and plates, but I've found water pitchers and extremely rare things like demitasse coffeepots, of which Vernon certainly made very few and which undoubtedly survived because nobody ever used them. The fact that they're for sale does not reflect an interest in pottery. It does not reflect an interest in Vernon certainly. It's just that dealers will say, 'Hey, this is a decorative object that I can sell.'

"What I think I have now is the most varied collection of Vernon. I know people who collect, for instance, particular Vernon lines who have extraordinary collections, where I just have a reasonable sampling of the pieces. But I have more examples of more of Vernon's entire production than anyone else I know."

"I guess Vernon felt that having nationally known artists work for them would be good for business. This is a series called Our America, which was designed by Rockwell Kent, a noted socialist realist painter, whose most prominent period was the 1930s and '40s. Each piece in the series has its own image. Our America is divided up into areas of the country. There's Chicago with the river, there's the industrial East, there's the South,

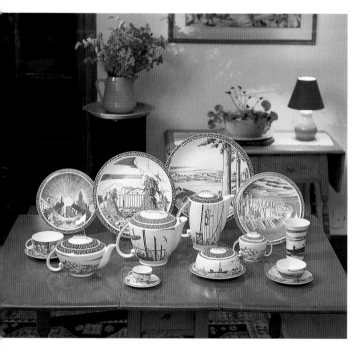

there are several items with the Great Lakes, and then there's the West. I have copies of ads from the period showing this, and it is clear that it was intended to be an actual dinnerware service.

"There's been only one piece of any pottery that I ever told myself I wanted, and that's the Our America coffeepot showing the construction of a major bridge [CENTER]. It's so beautiful from an artistic point of view, and the image suits the shape.

"I can't say I was looking for it, because I had no hope of finding it, but I was in New York, and a dealer friend said to me, 'Take this envelope, and don't look inside till you're far away, because you may love me or you may hate me for this.' As soon as I got downstairs, I did look inside and saw photographs and a letter from a woman in Virginia saying, 'I have the following dishware.'"

"So you saw the coffeepot."

"In a picture. Well, I saw the date of the letter, which was months earlier, and I thought, 'It's gone.'"

"So you were elated and disappointed..."

"Within the same breath. But I called her. She still had it. We ended up talking for weeks. She'd say, 'Well, the price...' and I'd say, 'I feel funny about offering you something...' and she'd say, 'But I don't know...' Finally I said, 'Look, find out what you think it's worth, and whatever you do, if you sell it to people who don't want damaged pieces'—the coffeepot, it turned out, was damaged—'I'll buy the coffeepot from you.' A week later the coffeepot arrived, unsolicited. It took my breath away. I picked up the phone and said, 'Oh, I can't believe this. You shouldn't do this.' She said, 'Well, I just thought that you should have it.'

"We continued talking. I told her, 'The dealer was going to pay you $300 for all the dishes. I have his notes. I will pay you $600.' She said no. I said, 'If he bought them and sent them to me, that's what he would do.' So she sent them. I sent her a check for $600. She sent me back a check for $300. This is two or three years ago. She's been here to visit. It's quite extraordinary. I've never had this kind of relationship out of dishes before."

"I had written an article about California pottery, and I said to my editor, 'You should come here and see this, because I don't think you know what you're dealing with.' She said she'd stop by on her way home, but then spent two hours looking at stuff.

"At some point I must have said, 'I don't think I have enough of this to…' And she said, 'Just a minute. Just one minute! You have shown me your kitchen cabinets. You have shown me your linen closet. You have shown me the pantry. You have shown me the credenza. And I haven't seen any sheets, any towels, any pots, or any pans, and don't tell me you don't have enough!'

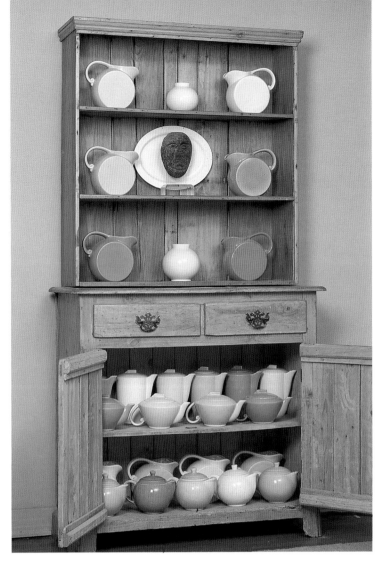

"Later a couple of young collectors from Florida came here. They had just started collecting Vernon and had seen very little. When they came in, they couldn't believe what they were seeing."

"Did they find it encouraging or discouraging?"

"Discouraging because there's not as much in Florida, but encouraging because there's clearly so much around."

"They might have come here and felt that it's too late."

"Well, it is late, but it's not too late. The more interest there is in this, the more of it is going to be saved from destruction. It's not going to be used or broken. Instead of people who are going to use it as everyday dishes buying it in thrift stores, dealers will buy it and sell it to collectors. This whole process is a process of saving part of our design heritage." •

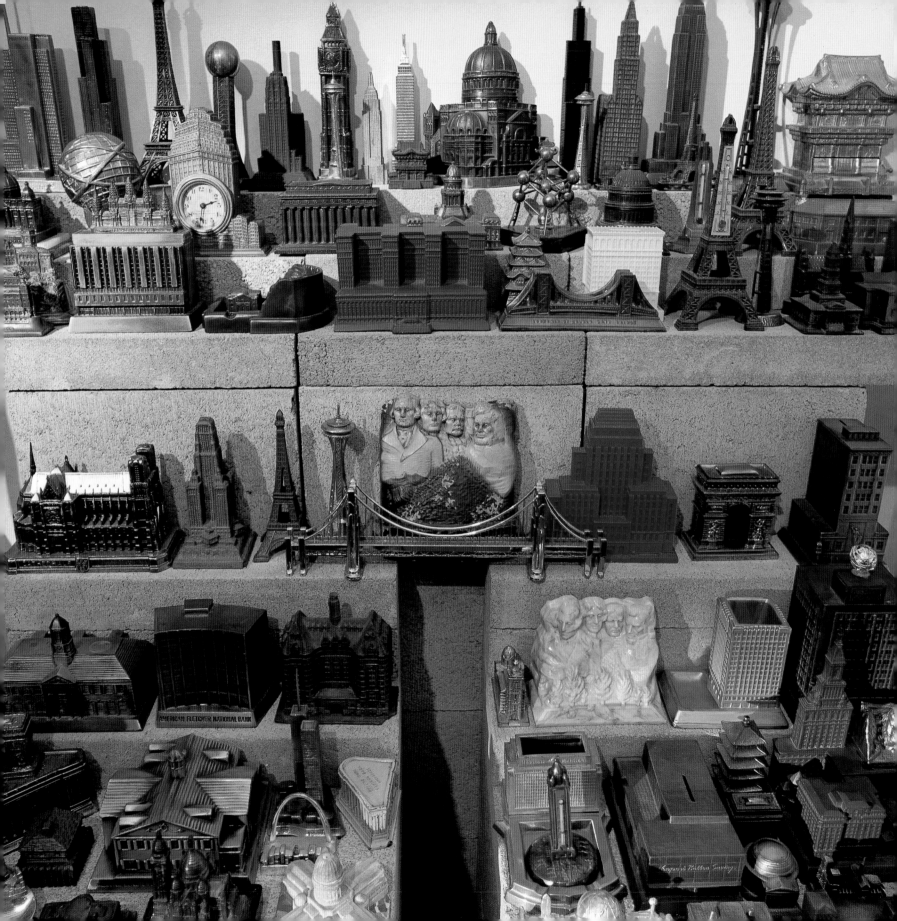

Steve Schwartz

Motion picture and theme park designer

Souvenir buildings

hat are we looking at here?"

"The world. The world as it once was, as it never will be, as it could be. Some very distorted images. This is sort of like our collective memory in physical form. It exists in all of our minds."

Steve Schwartz gazes as if with fresh eyes at an impressive arrangement of replicas of some of the world's best-known architectural monuments—the Empire State Building, Eiffel Tower, Boulder Dam—and others not nearly so well known—the headquarters of Prudential Life Insurance in Chicago, the Woolworth Building in New York City, the opera house in Prague. The world, or some version of it, more mythic than make-believe.

This is not so different from the souvenir worlds he has designed for theme parks in Florida and France. For the studio tour next door to Euro Disney, "we started with a very important Hollywood icon, Graumann's Chinese Theater, and put it in its historical context. We took recognizable images of buildings and sort of collided them together, creating the atmosphere of the boulevard in that time. In other words, we did Hollywood Boulevard in the '30s and '40s. It's like a backlot set of Hollywood Boulevard at that time, dressed as if it were a hot set, ready to shoot."

"A playland," he calls it, "a lot of recognizable imagery clumped together that you walk through."

69

There's a playland in his living room too. "I've played at laying out entire cities with these buildings in different kinds of schemes, and it's a lot of fun to make a little vignette that way. But this is not really set up for that. It's just mainly display.

"My attraction started with Empire State buildings. I wasn't really serious, but when I'd see them, I'd buy them. After I had maybe five or six, they started to look pretty good together, so I began seeking them out in collectibles shops and junk stores. Then I realized that I was seeing a lot of other interesting buildings, souvenir buildings. The

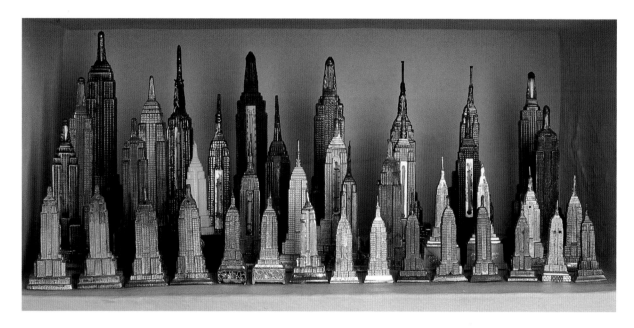

Empire State Building is still one of the major tourist destinations in New York. It was the tallest building in the world for a very long time. The replicas are not all proportionately correct.

"Some of these are salt and pepper shakers, paperweights. I have one that's a pencil sharpener and pencil holder. And, of course, there are thermometers. It's always been my intention to one day design a high rise with a big thermometer going right up the middle, so that the building itself actually becomes a souvenir.

"My favorite Empire State Building is also the biggest. It doesn't fit on the shelf with the others. It's closer to the proportions of the actual building, which I like. I got it on a movie set. I was working at Universal Studios at the time on *Jaws: The Revenge*, and there was another film being shot there at the time. I think it was *Gremlins*, and this was part of the set dressing. The decorator knew I collected these, and after the shoot saved it for me.

"

This is the Lefcourt-State Building on the northwest corner of Broadway and 37th Street in New York. It's put in context with the street, and yet it's out of scale with the street. The building is presented as if you were standing on the corner. As you look up the side, you can see that it's diminishing in perspective. And, of course, there's this big, round clock embedded in it that says, 'Time to visit the Lefcourt-State [building] N.Y.'

"To the left of it is the Air-View Terminal Tower in 'Cleveland, O.' You can see how it too has a forced perspective, but it's smaller at the bottom and, as it rises, it gets broader. It gives the illusion that it's even bigger than it is. It's sort of accentuating itself in your memory, even though it's only two inches tall. I like it when buildings get distorted in a souvenir."

"What has surprised you most to discover as a replica?"

"Well, how about this one? This is the National Building of the Women's Christian Temperance Union [LEFT, REAR] in Chicago, Illinois. The date is 1891. It's quite surprising to see, and it's quite substantial. They had a big building.

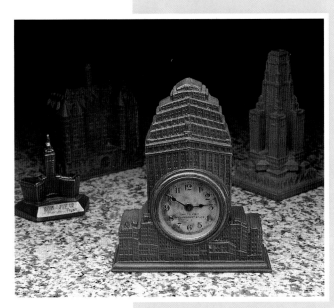

"I got the one on the right in Washington, D.C., and I had a hard time getting it away from the dealer, who did not want to sell it. This was a souvenir from the Chicago World's Fair, but it never existed as a building. It was part of the World of Tomorrow, and you could buy souvenirs of something that was only a concept, an idea. This is a peculiar building because it's a skyscraper, yet it appears to have log cabins and a fortress as its base, and it's up on a rocky cliff. So it's really the future rising out of the past of the frontier.

"

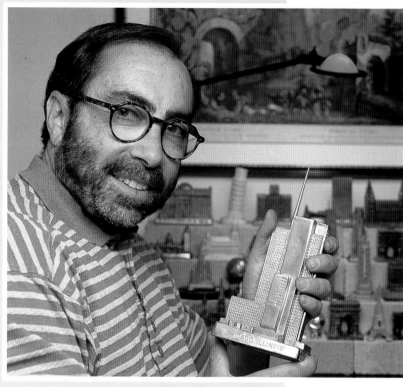

"

Quite honestly I think some of these are so poorly made that you can see that the manufacturers were just out to make money, though some of the ones that are poorly made can be charming because they're so badly distorted. Other times people are quite serious about their image. This is a replica of the Prudential Life Insurance building in Chicago. It's all in silver and very carefully crafted. It's really meant to connote an image of sturdiness and beauty and everything the insurance company wants you to think about. It's also happens to be a bank.

"

"When I first started seeing this collection come together and how much fun it was, I went around to all the available places in my neighborhood and just went shopping, literally picking buildings off the shelves. Then my radius extended farther and farther. I found myself on shopping trips up to Santa Barbara, out to Riverside, and down to Palm Springs. Actually it was a fun way to get out of town, really see a place, experience the architecture and the environment, and bring back these souvenirs.

"I think the whole idea of souvenirs is more interesting to me than the fact that these are miniatures, a souvenir being something that you take away from a place to kind of relive the experience. I was attracted to them as souvenirs but not necessarily as souvenirs of where I'd been. Still I can look at these buildings and remember being out in the backroads of Virginia and stopping at somebody's little shop in some small town; as a souvenir, it may be a building in Boston, but I look at it and recollect Virginia.

"Over the years I've been involved [as a set designer] in making movies on location, which has brought me into parts of the country that have a lot of antique stores, and on my Sundays off I would spend the day combing the countryside and come back from a film with maybe forty or fifty buildings in my suitcase.

"The first thing I do with a newly acquired building is carefully take the dust off, leaving the patina. Then it gets set out. Because I'm filled to the max of display room, adding a piece is quite an experience, because if I really want it out, I've got to start moving things around. And once I get involved in moving things around, everything in the whole room can get reorganized, and I'm obsessed for hours.

"I have no room to put buildings anymore, so I have several of these arrangements scattered about the room. This one's pretty casual and fluctuates with the tremors that we have here in Los Angeles." ●

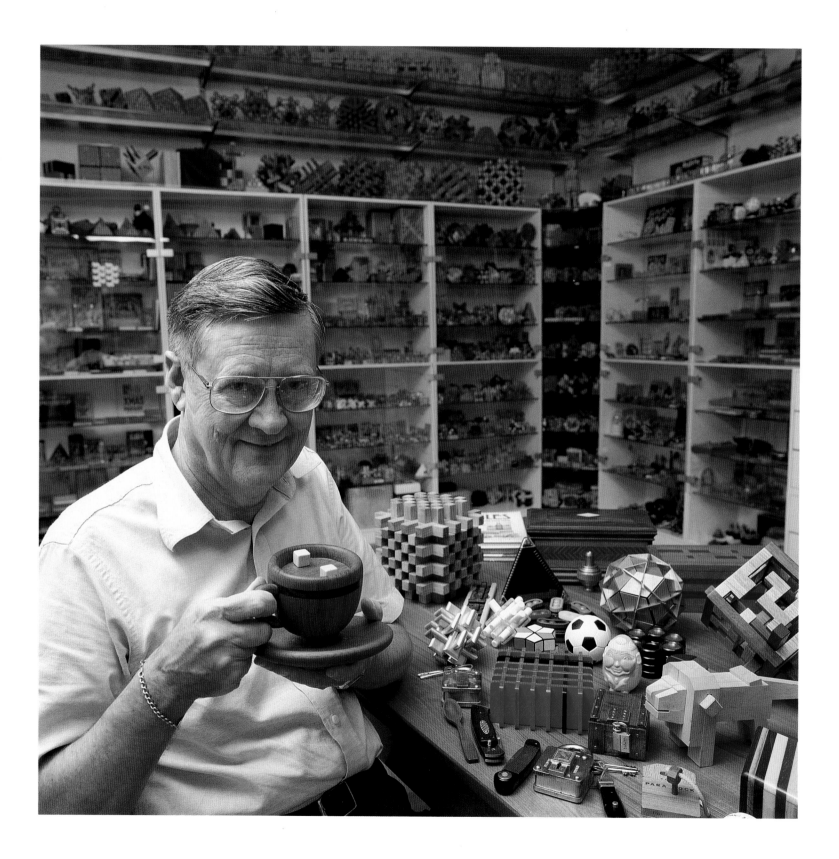

Jerry Slocum

Aerospace engineer

erry Slocum acquired so many mind-boggling puzzles in forty years of devoted collecting that he built them a house of their own: a compact, light- and climate-controlled environment specifically designed to display and preserve them. There he can work privately on any of his numerous publications or entertain and challenge wide-eyed guests.

"Does either one of you know the T puzzle? The object is to form a T, a capital T, a perfect capital T, with these four pieces. If you know the solution, fine. If you don't, it's very difficult, and to me it's a very elegant puzzle.

"Do you know this one? Two pieces make a pyramid, in this case a tetrahedron. It's only two pieces, not as difficult as the T, but it's not a trivial puzzle, and people will struggle with it.

"And here's another one that I think is really elegant, very simple conceptually. Take an ordinary nail. The puzzle is to balance six other nails on the head of the first one. No glue, no magnets, nothing except these six nails balanced on the head of this other one. To me that's a very elegant puzzle, and it's extremely logical if you know the right questions to ask. If you don't, you can struggle with it for hours and not come up with the solution.

he tangram is a very famous puzzle developed in China. It consists of seven pieces, geometric pieces. The problem is to take these pieces and form different figures with them. It's kind of the inverse of a jigsaw puzzle. You can be creative and invent your own designs, but there's a series of preset problems. This is a book of problems from about 1800 [LEFT, CENTER] with a carved ivory cover and silk pages with paintings. This is a very early version; they're just outlines in plain color: people, geometric forms, animals, chickens, houses, and so forth.

"This puzzle spread very rapidly in the early 1800s. The Italians in Florence in 1818 had a book of tangram problems—same seven pieces— but they interpreted the problems architecturally with pyramids, buildings, monuments [CENTER]. The outlines of these are all the same as the problems from China, but you can see what a vast difference there is in the interpretation of the puzzle.

"Here's how the French interpreted the same puzzle. You'll see from the early 1800s they anthropomorphized things with faces instead of buildings, people, predominantly people, and some animals, but relatively few geometric shapes.

"If you look at the very earliest American versions of the same puzzle, you find that we tended to follow the French. This is the earliest McLoughlin Bros. puzzle. These are hand-painted problems, but you'll notice they're direct copies [of the French] with the pieces in mahogany and the key with the answers in a separate little book.

"The puzzle that intrigues me most is the one with just a few pieces but a design that leads you away, the experience or configuration leads you away from the solution, and it requires insight and thinking in a different way in order to solve it.

"It must be self-contained. A puzzle cannot require magnets out of your pocket or things up your sleeve. This is a puzzle box that I just got from Japan. It requires 122 moves to open it, which is about two to one more moves than any other puzzle box I've ever seen. I couldn't put this thing down until I'd solved it, which I did.

"From the time I first started, it was the problem of how to solve a puzzle that really intrigued me. It was an incredible satisfaction, if it was complicated and difficult, to figure one of these out.

"I was born and brought up in Chicago during the Depression, and my parents enjoyed traveling. So they would travel, and they would bring me back puzzles. By the time I was in high school, I had a collection, an embryonic collection.

"I've always been interested in mechanical things. I have a degree in mechanical engineering with a minor, as an undergraduate, in psychology and perception. In college I made a lot of puzzles. I bought all the books that I could find that had any puzzles in them. Then, just at the time when I graduated, 1955, I published an article in *Science and Mechanics* magazine on how to make and solve puzzles and included a picture of me, my wife, my puzzle collection, and my address. So, starting in 1955 I was getting letters from the coast of Africa and Europe and all over the world, and my network started at that time. I'm still in touch with some of those people.

"Today if I see a puzzle I don't have, I'll buy it no matter what. Recently I have been acquiring at the rate of about three a day, a thousand a year. I have over 18,000 puzzles. I find them in antique shops or through antique dealers by word of mouth. I have a network of people that I write to and dealers all around the world and other collectors that I trade with. In fact, there's more trading than buying, because it takes so much time to find them, the old ones, I mean, a lot of these old American ones and British ones. You cannot go out and find these.

"Somebody new in the field says, 'How could you possibly have hundreds of these, let alone thousands?' Well, they're very, very difficult to find. Some of the German ones, for example: these are difficult to find anywhere in the world. Most of the ones you see here were willed to me by people in Germany. I corresponded with them for years, sent them materials, and got to know them. I've interviewed the descendants of the founders of the Richter puzzle company. I've been to their plant in Rudolstadt, Germany, and really got into this.

77

PUZZLES

"

Here's a chest of Chinese puzzles made in about 1820. Chests like this, made in Canton and Shanghai and other craft centers in China, were essentially custom-made. I've seen fifty or a hundred of these, but I've never seen two that were exactly alike. These boxes were mostly made as gifts from the captains of the China clippers, which sailed from China to Salem, Massachusetts, and San Francisco and Philadelphia and New York, to the merchant owners of the companies that were buying all the silks and tea and so forth from China.

"A lot of the dominant China trade, the merchant families, were in the New England area, and at that time in New England there was a strong prohibition against playing cards and games and dancing, but the church made no rules against playing with puzzles. So, in fact, in the Salem-Boston area these were called Sunday boxes. The family would play with them on Sundays. There were mostly puzzles, but a few amusements too. Here you see pickup sticks, and here you see matchsticks for doing matchstick types of puzzles. And this is an amusement where you see three strings [connecting two ivory rods]; then five [connecting the next two rods]; then six; two; four; and so forth. This was kind of an amazing amusement in those days. Actually stringing these is not a trivial problem. It was written up in *Scientific American* in about 1890.

"

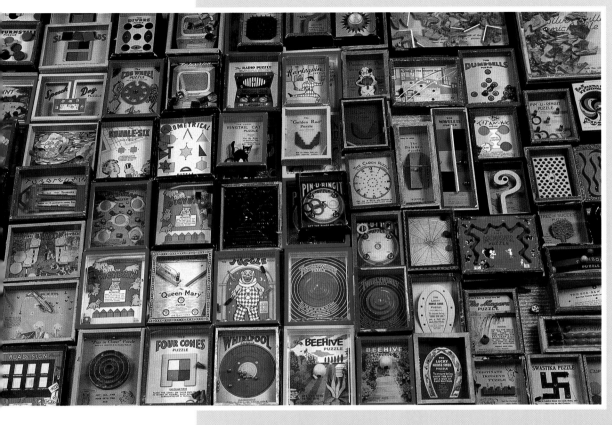

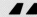

"The company that made the best overall dexterity puzzles was a British company called Journet. These people really did a good job of innovating and designing, and they're virtually all good puzzles. They're difficult. They require different kinds of approaches.

"Journet puzzles like these were included in 'care packages' that were given by the Red Cross to British prisoners of war in German prison camps in World War I. In many of these puzzles Journet included a hacksaw blade, a compass, and a map to allow the prisoners to escape and get back behind the lines. You had to take them apart in other words.

"I have been asked on several occasions, 'Did anybody ever escape using this?' and I don't have an answer. Even the son of the owner didn't know."

"

People ask me, 'Are there any really old puzzles?' Well, most puzzles are not made of permanent materials, but the ivory ones survive, and the ceramic ones survive. This kind of puzzle jug was filled with a liquid—beer, wine, or whatever—and the puzzle was to drink without spilling.

"It is possible, and the solution is very interesting. Most people can figure it out given a bit of time and experiment. In fact, the jug has a built-in straw. You cover the hole under the handle and suck on one of the holes in the rim. The liquid passes from the bottom, up the handle, and around the rim.

"I think probably the most successful research I've done into the origins of puzzles is in the area of the ceramic ones. I've traced these puzzle jugs back into the Roman and Greek era and actually to the tenth century before Christ.

"

"There are hundreds of collectors now, and I have been very active in helping people to understand the intriguing aspects of puzzles and the scope and breadth of puzzles. The exhibition, *Puzzles: Old and New*, is just one example. My first book, also called *Puzzles: Old and New*, and my second, *New Book of Puzzles: 101 Classic and Modern Puzzles to Make and Solve*, is another. And I hold a puzzle party, which I started about fifteen years ago. We've had eleven of them now. At the last one we had 183 people, so I couldn't have it in my living room. We had it at the Pacifica Hotel [Culver City, California] two days. The first day the rules were that the only people who could get in had to bring fifty high-quality, unusual puzzles to give away. It could be fifty different puzzles or fifty of one puzzle. Fifty people came, and they went back with fifty different puzzles, and they just loved it. The second day we invited vendors and people who design puzzles and people who manufacture puzzles and people who are just interested in puzzles, and we had a puzzle party all day.

"If I look at the people that I know who are puzzle collectors and solvers, there are more mathematicians and computer people than there are diplomats, but we do have diplomats. We have fishermen, woodworkers, people from virtually all walks of life. I think one thing that's common is, a lot of people are turned off by puzzles because they just don't want to be frustrated. They don't want to look bad by not being able to instantly solve something. They want to be in control. With a puzzle there's a certain element of not being in control and sort of being vulnerable. I think those people that like puzzles are willing to be puzzled, are willing to look a little foolish and to show they can't solve a puzzle. This patience and vulnerability, I think, is more of a factor than intelligence per se. Curiosity and patience, persistence and dealing with things that appear to be intractable." ●

Clare Graham

Production designer

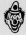

Most people collect objects whose aesthetic qualities are well established or at least rising in general esteem. The aestheticizing of something that is not widely respected, that is, indeed, flatly renounced, takes a singular sensibility. Clare Graham collects many things. What links them is a sense of disrepute. Some, like his hundreds of abused and bedraggled carnival punks, he collects and idolizes. Others, like his thousands of dominoes and millions of poptops, he collects and transforms. Even then, he admits, "It's such a private vision that the appeal to someone else is really one of awe rather than appreciation. It's kind of 'Oh, my God, why would somebody do that?'"

83

"*Punk*. It's an old carny word as far as I know, though I don't know the exact derivation. Usually a rack had six punks in each of five horizontal rows stacked vertically, though I guess you could arrange your rack in any way you wanted. I've also seen punks in concert with those aluminum milk bottles that they put in stacks of three.

"You took your swing at punks with baseballs. The object was to try to knock the punks down. The large ones are so much heavier, it would take a much stronger throw to knock those guys over—a bigger target but harder to knock over. The old ones, the ones that date to about 1860, are filled with straw and horsehair. This set [FRONT ROW] is real old and has sawdust inside. Almost all of them are just canvas stuffed, however, and have a wood base so they naturally are heavier on the bottom.

"The earlier ones are strict knockdown. Most punks, however, are done with a block of wood on the bottom and a hinge so that a guy with a stick could reset them without getting in the line of fire. If you examine a punk rack, you'll see that there are certain ways that the hinge could be magnetized so that it popped open slightly but then snapped shut. Then there's the whole controversy about whether some of them were weighted."

"Are you telling us that gambling isn't always on the up and up?"

"There's a definite aesthetic that all the punks represent, all these little staring faces that are just happy and smiling and get pummeled with baseballs and knocked down and abused and worn out. The ones that are repainted over and over again as they go through the generations, they're well-traveled and well-used objects. The ones with the greatest patina I actually like the best; they have a lot of character.

"I guess my taste in art has always been way beyond what my pocketbook would allow me to buy. I started looking at very early iconographic Cycladic art, those staring, marble, carved things; they're just absolutely stunning images for me. Then I found a set of punks with the same weird, staring, very demanding kind of physiognomy. I really liked that feeling of silent sentinels. They sort of filled in for things I couldn't afford, and then it just took over. I started collecting them because they'd had that kind of abused treatment; nobody was respecting them for what they were.

"When I started buying punks, they were dirt cheap. They were plentiful. At almost every swap meet you would find one or two or a couple or a brace of them. Now the Carl Hammer Gallery in Chicago sends me mailers of what they have for sale, and recently a set of punks—there were thirty-two in the set—sold for something like $18,000."

"And you say you have how many?"

"I probably have between 450 and 500."

"Do you continue collecting them?"

"Oh, yeah."

"So there's no particular end."

"There's no end in sight."

"How widespread do you think these were?"

"Virtually across the entire U.S. They're not really marked in any way. A couple of mine have manufacturers' tags. A lot of them were associated with the East Coast gaming piers like Coney Island and Atlantic City. Out here on the West Coast they were at Pacific Ocean Park, and when I first moved to California in 1964, I went down to the old Cyclone Racer at the Pike in Long Beach, and they still had punk setups there. There are punk racks to this day, like at the L.A. county fair, and there's still a manufacturer of the real cheap ones with the fur outlines. You can still buy four or five different patterns."

"Are they all manufactured items, or were any of them homemades and one-offs?"

"Oh, definitely homemade. This one [FRONT ROW, LEFT], which is a real early one, is handmade from start to finish. It has short, nappy hair, which has graphite rubbed into it, and the cloth—somebody traced it—is a Civil War sheeting. I have a rack of fence-sitting Indians—they had little feathers on them—and were obviously made for somebody's school or church carnival. There is a whole handmade set that's got Hitler [BACK ROW, CENTER] and various other personages.

"The larger ones are almost always cats. I've seen them displayed on fences, so it's like knocking a cat off a fence at night when they're howling. You would naturally throw something at them then despite their happy, smiling faces."

"There's a definite kind of obsession I have with quantity. I like multiples. I like what happens when you get all that stuff together, and in my own art I started needing more and more of something to do it with. It began with dominoes. I did a suite of Frank Lloyd Wright-ish furniture that included a big table and stands. I ended up using a total of 53,860. But collecting dominoes started adding up to a lot of money. Then the game became, what could I find that I could get more multiples of? What's out there that's a discarded item? And I came up with bottlecaps. By scamming on the distributors and having people collect them from bars and restaurants and hotels and convention centers, from going in and saying, 'Would you mind throwing them into this box for me?' I got close to 3.5 million bottlecaps for no outlay except shipping charges.

"What I found too from dominoes to bottlecaps was that the parts were getting smaller and smaller and the incidence of repeat was increasing within a given space. That was definitely a trend. So then the game became, now what do I do to find something that I can get even more of than I did bottlecaps. One of the visitors to the L. A. Modernism [twentieth-century design] Show in Santa Monica [where Graham exhibited bottlecap art in 1991] was standing talking to me about it and drinking a soda from a can, and she sort of twisted the poptop back and forth and said, 'Here's what you can use. You can get more of these, because they weigh less, and they're smaller.' So I said, 'OK, let me try that.' I now have eight thirty-five-gallon trash cans filled to the brim with poptops. I probably used

This is called plaiting, and it's very complex. It takes a certain kind of mathematical mind to figure out the incidence of over and under and the way to weave it to make a shape turn corners. It's so complex that I haven't figured out how to do some of the shapes yet.

"Plaiting is one of those games that artists play about immersing oneself enough in the material and the technique that you discover the way the material directs itself. That's what I did with the bottlecaps and poptops. You get to a point where the respect you have for the material is dictated by its inherent qualities. You can't really violate that, or it doesn't make sense anymore.

"The very best plaited objects, I think probably the very earliest ones, are from prisons and are sort of commemorative things. They're somehow a personal object or response that wasn't made for sale; it wasn't made as a gift.

"These baby shoes: those are all the little palm trees off Camel cigarette packs. Each one of those palm trees represents a different pack of cigarettes because there's only one on every packet.

"The popular myth is that it's all prison art. Probably some of the ones that are Camel cigarette packs are from prison, but many of the rest are being done now in Mexico, and it's not even cigarette wrappers anymore; it's just foiled paper.

3 million or so making the project that was at last year's Modernism Show.

"The dice you see will turn into something eventually too, though I'm not sure what form that's going to take, and I'm using swizzle sticks too. I'm making a big screen that has 30,000 swizzle sticks.

"The Camel cigarette pack art and the matchbook art: that's why we like all that, because it's the same kind of mind and technique that would sit down and labor over something that's of no material value. I mean, there isn't ten dollars worth of material in the bottlecap stuff; there's nothing. It's something that people throw out of their houses every day."

"You don't seem to make a distinction here between the objects you've made and the ones other people have made."

"No, because I guess I don't recognize much of a distinction between these objects and what we do with them here and things I buy and manipulate into other forms. The art I produce I would like to have end up anonymously in other people's collections without a name or a tag or anything of that kind." ●

CARNIVAL PUNKS
AND TRAMP ART

Patricia Geller

Interior designer

e first encountered a single example of Patricia Geller's collection of mostly seventeenth-century mannequins during a temporary installation at the Los Angeles County Museum of Art. She and her partner, Cissie Cooper, in the interior design firm of Cooper/Everly Design Services, had placed a startlingly tall and strikingly beautiful torso of a woman before Julius L. Stewart's painting The Baptism, *a vast, late nineteenth-century tableau of a ceremony staged in a palatial American home. The serene wooden figure assumed the role of a guardian angel, in keeping with the beneficence that radiates from the painting, though never so palpably as on that day.*

88

"I was raised a Catholic, and I was used to seeing figures of saints in the church and having mysterious feelings about them and loving feelings about them, feeling that they were my friends and protecting me. These figures represent people who are filling my home with love and happiness. That's why I wanted the beautiful faces as well, peaceful expressions and loving feelings emanating from them. If you look at the art in my house, you'll see from a lot of the sculpture and paintings that I have a fascination with figures and faces."

The collection, slowly growing, comprises just fifteen figures, but quantity seems irrelevant, given the precise—almost deliberate—way in which they are dispersed among the rooms of Patricia and Marshall Geller's house, never more than two to a room, never side by side, each figure beckoning or commanding attention.

"I think they're visually so compelling and strong, each of them on their own, that you can't look at them together. They need their own energy around them, not to be interfered with by others. They have a spirit about them, like people do, and they take up space more than a painting would or a sculpture. They seem to me to have a life of their own and really command whatever space you put them in. So, for instance, with the largest piece, she had to have virtually a wall of her own because everything just distracted from her. They really dictate to you where they need to go.

"It's becoming more difficult, as there are more of them, to give them their own space. Eventually, I think the only other possibility would be to have one room where they would be installed together."

Distinctive though the figures may be—their height, for instance, varies from less than twelve inches to more than seven feet—they have certain common traits. Though some are fully modeled, more often the head, torso, and hands are the only fully realized parts. Their spare, conical bases indicate that they were intended to be dressed.

"I've come to understand that these were used for two purposes. One, they were used religiously, some of them, in churches and processions. They represented saints generally. They were also used as mannequins in shops, where dresses and other clothing in miniature versions would be displayed.

"I think that the work itself is very lovely. You know, there's beautiful detail. They were really artists who carved these pieces, though they probably didn't get credit in their day. Some are carved entirely of wood. Sometimes the bodies are wood, and the heads are terra-cotta. And some of them...see her glass eyes? Others just have painted

eyes. A lot of them have pierced ears. A lot of times they had wigs. You'll see a little nail in their heads that must have been to hold their wigs in place.

"I have a couple of figures that have their original clothing, but I wouldn't dress them unless I found something that was of the period, and it's very difficult now to find such clothing. You find remnants. Anyway I like seeing their forms. The form itself is very appealing to me as well.

"A lot of them may have been treated badly over the years. It's difficult to find them sometimes with their hands in good condition. I have some that aren't in such great shape, but I love them, the aura about them. I haven't restored any of them."

"If you look at these two faces [the towering figure and the one reflected in the mirror], they're very similar. I bought them both in Florence, and I was told that this is the face of a Lucan, a person from Luca, a typical bone structure.

"There are a number of mannequins around that have grotesque faces, and in fact, I have one called the *dolorossa* [RIGHT, REAR], which means the sad one, but there was something else, an inner beauty that radiated from her. The *dolorossa* is a seated figure, and she just happened to fit perfectly into that chair. There was really no other place that would have worked as well as that did. The chair is very low to the ground, and it just suited her. It wasn't overpowering for her figure.

"The *dolorossa* is Italian. The peasant woman [LEFT, REAR] I believe is French. That is her original costume and original stand, but I can't imagine what she was used for."

"*But you call them all mannequins, regardless of whether they were meant for display or ecclesiastical purposes?*"

"Yes."

"he first two I bought in a shop called Luciano in Carmel. The owner had a private collection of mannequins, and he happened to be selling some of them. This was the very first one. I saw her and fell in love with her. I felt she was reminiscent of me, because she has my coloring; I've always had very red cheeks. And the ears were shaped like mine; they stick out a little funny like mine do. As I've watched it over the years, I see the paint's crumbling a little. It's kind of like the picture of Dorian Gray."

"After you bought the first one, did you have a feeling that this was going to be a collection?"

"Yes. I have a resource in Florence, a woman who collects them from the countryside in Italy, and there's a woman who has a shop in New York who travels to Brussels a lot, and she finds them generally there, and they come from Portugal and Spain as well.

"In the beginning when I would buy an additional figure, my husband would say, 'Why do you need another one? You have enough.' And then as it became more of a collection, he understood. **"**

"They're becoming more and more difficult to find, and there are some that are better quality than others, but when I do find them, there are certain ones that I'm drawn to. First of all, I always like to find those that are particularly beautiful.

"I think my partner, Cissie, and I have a pretty good eye for unique objects. That's what we enjoy about decorating, finding wonderful things. We like to find unusual objects and not just create another designer interior, which means reproductions and the same thing you've seen twelve times in twelve different houses."

"Do you, in fact, find yourselves building collections in other people's homes?"

"Yes, absolutely. And sometimes I hesitate to show certain beautiful objects to clients, thinking how well they would fit into my home." •

93

MANNEQUINS

Mike Farrior

Landscape contractor and Avalon Tuna Club historian

Angling equipment

ou can imagine Mike Farrior's collection ensconced in the dark-stained walnut and glass cabinets lining the trophy room of a venerable, patrician, yet sadly neglected men's club. It is not inconceivable that parts of the collection actually have been rescued from just such venues since the world of deep-sea angling was itself, until the final years of the Great Depression, a rather exclusive men's club, run according to rules that defined the gentleman angler in terms of fair play for fish and keen competition among sportsmen. In this privileged realm the accoutrements of sport were custom-made and costly. Rare then, they are a veritable endangered species now.

94

"Fishing for food has been around since the dawn of time, but fishing for sport, particularly for big-game saltwater species, is a relatively modern concept. The sport as we know it today was founded just before the turn of the century around Catalina Island. Big-game fish would include those species we find offshore, such as tuna, marlin, and broadbill swordfish. These catches were nearly exclusive to this coast up until about 1910, when the concept of big-game fishing started to spread around the world.

"The development of big-game tackle began with 'the New York phenomenon,' as I call it. Anglers were catching striped bass as early as 1840 from the shore with what is

known as the New York ball-handled reel. It was probably our earliest serious saltwater reel, featuring a free spool and a large ball counterweight on its handle that enabled anglers to cast great distances. Toward the end of the century beautiful reels, designed less for casting and more for strength and greater line capacity, were developed for the capture of saltwater species, such as tarpon, from boats in warmer Southern waters. By the late 1880s these Eastern anglers had brought the sport to Southern California.

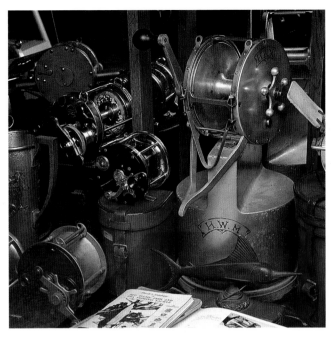

"The reels that were first used here were called knucklebusters, because when a large fish struck the bait, the direct-drive reel's handle would spin backwards, just like a buzz saw. They were literally breaking tackle and hands trying to stop these fish.

"The fact is that fishing in those days was very expensive. Some of the reels I have in the case here were over $75 around the 1890s and the 1910s. That would have been a tremendous amount of money for the time and did not include the lines, the rods, or hiring the boatman. So big-game fishing was, at least in its early days, largely confined to people of means, just because of the sheer expense involved.

"The interesting thing about old fishing tackle is that there's very little known about it. You'd be pretty hard pressed to find detailed information about the way reels really worked and how tackle was rigged. That's why I've made a point of collecting old books, to get firsthand information about how they did it and why certain things are important and why some aren't; some things that aren't very valuable may still have a historical significance. Old paper goods are very helpful. You can learn a tremendous amount from the catalogues that were used to order tackle. That educational process I put myself through is what has enabled me to compile the collection, to recognize those things that are historically important as they come along.

95

"My collection is a representative collection of big-game saltwater sport-fishing memorabilia. It includes lures, terminal tackle of all types, magazines, catalogues, books, reels, rods, lines, and any associated memorabilia of that period, the mid-1880s up until the mid-1930s, that being when many custom and experimental reels and rods that represent the evolution of this type of tackle were made.

"I'm familiar with the makers, as they called themselves in this period, and I know what models and types of things they manufactured through the years. I know who

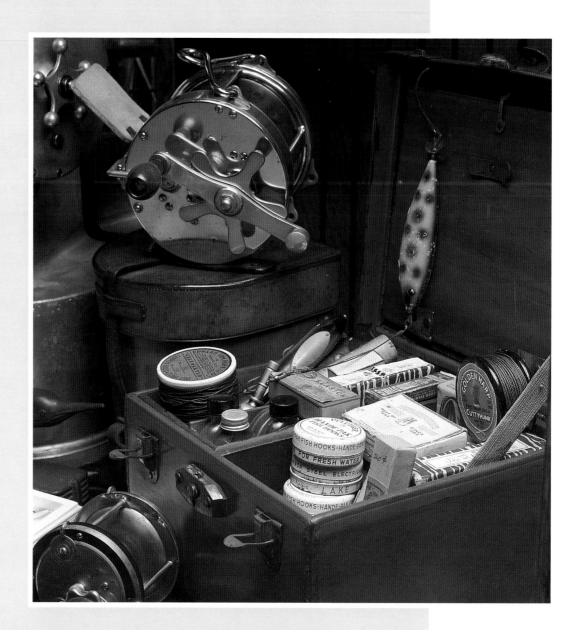

"

In a general sense, tackle defines all that is used in sport fishing—everything. A tackle box, for instance, would have every component you might need. Tackle is everywhere and all around you on the boat. It's everything from oil to line to wrenches to lures, weights, anything. When you're doing a lot of fishing, you're constantly in the box.

"

mass-produced and who custom-made, and I lean primarily toward the custom-made. I generally know the reels I'm looking for as opposed to just collecting masses of things. In assembling a collection I basically am targeting.

"Many of the makers combined their skills as expert craftsmen with their experience as anglers. The list would include Frederick vom Hofe, his sons, Julius and Edward, Bates, Conroy, Leonard, Meek, Milam, Wilke, and more recently Mitchell-Henry, Kavolovsky, Stead, Lee, Klein, Garey, Coxe, and Stevens.

"Another thing I work very hard to do is buy pieces that are in good condition. As with all collectibles, condition is very important. Obviously you'll take a beater if it's all you've got to represent what you're looking for. But condition's important.

"I have people picking for me everywhere because a lot of them know I collect. Sometimes I'll get a call from someone who will say, 'I have this really great rod and reel outfit. You're just going to love this. You're not going to believe it. You've got to come over and see it,' and most often it's what you call junk. It's something that was mass-produced, and although it might have an early patent on it, it was a 38¢ reel when it was made, it's a 38¢ reel today. And you know, you have a hard time not hurting people's feelings. It happens to me all the time."

"Are you the first person the widow calls?"

"Not as much as in the past. I have slowed down on the public exposure that I used to feel was an important tool in collecting. I used to do a fair amount of writing, and I gave talks at fishing club meetings and that sort of thing. I would also attend regional fishing shows, where I'd set up a booth, and people would say, 'You're not selling anything. How do you make money on this?' And I said, 'I'm not making money. I'm looking to buy.' I got millions of questions, but just about every day, almost like clockwork, somewhere in there I'd get a good lead. I'd get lists of people who said, 'My grandfather had this.' Most of it was junk, and then I'd get a real bingo in there. After the show's over, I'd have maybe ten or twelve nice pieces. I just got a real kick out of finding them.

"When you work for several years like that and have a lot of public exposure, yes, you get the widow calls. Anyway it was a time when very few people were collecting old saltwater fishing tackle, and most people could not understand what I was doing. Now I don't think you could put a collection like this together that easily because there was not that much of it made and more are collecting it.

"Why have you restricted yourself to saltwater fishing?"

"Well, you just can't do everything and do it right. Big-game fishing always had a romantic side for me, so that's just what I wanted to do. I've seen too many collectors try to get into this sort of thing, and they just go nuts. They fill up a room with such an assortment that there is no definitive collection.

"

This is a random sampling of saltwater lures from about the turn of the century up until about the mid-1930s. They would have been used on a variety of species from small to very large game. The biggest ones here are known as teasers. They were designed to swim erratically directly behind the boat in the wake. When a marlin was sighted hitting them with his bill, an angler would drop a hooked bait into the wake—you hear the term "drop back"—and then generally the marlin would eat the bait. Teasers were never intended to carry hooks in them.

"Red and white have always been good lure colors. We don't really know a lot about what fish see, but we do know that some colors work better on different days and in different lights.

"If I had to say which are the oldest lures here, I would guess it would be this little, dull gray 'spoon' [NEAR CENTER] with definitely a homemade hook affair. It's kind of a folky thing. These two tuna jigs—the blue and white and the tan and red—are quite old. And this particular one that looks like a silver fish is all hammered and hand cut. It's a lot of work. Typically you'd find that sort of effort being put in prior to commercial products being available. In terms of commercially available lures and age, this bone jig [JUST BELOW THE 'SPOON'] I know to be quite old because the gentleman who used it fished in the Tuna Club very close to the turn of the century.

"The spotted one, the yellow one [NEXT TO IT] also, and the crackle back right there too: those are all Heddon coast minnows from about 1910. The Heddon coast minnows are probably a good $400 to 500 bait. The Catalina minnow down here with the green back [BELOW THE BONE JIG] is close to that, you know, $350. And then others might be $75 to 80.

"

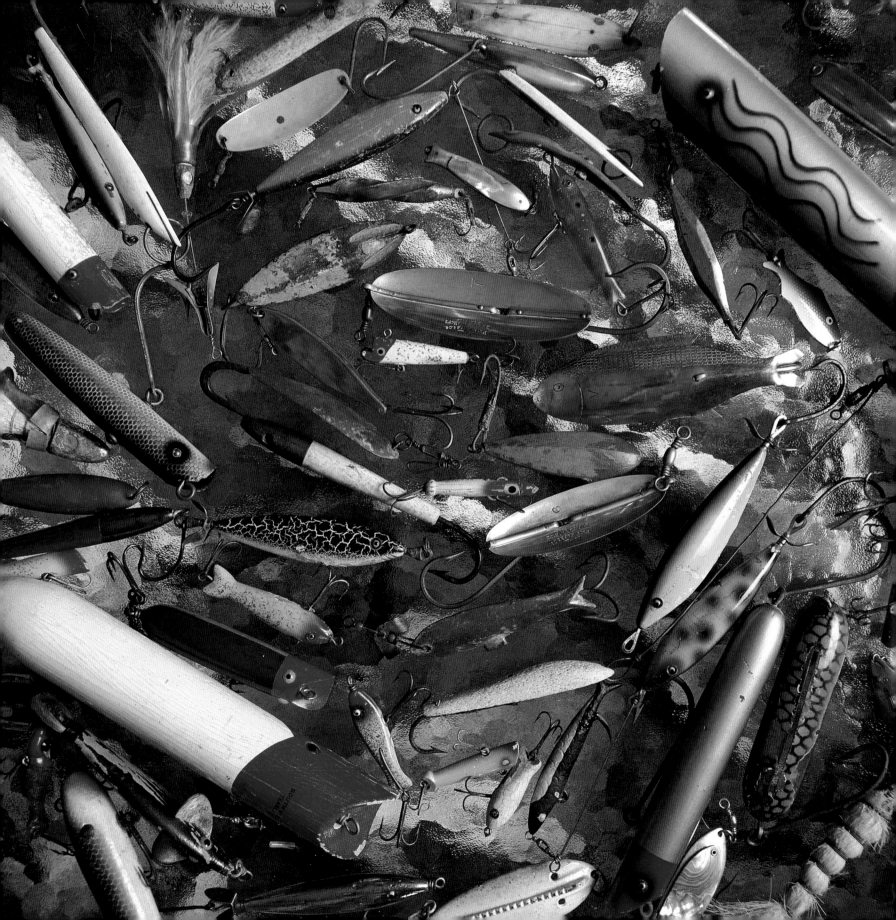

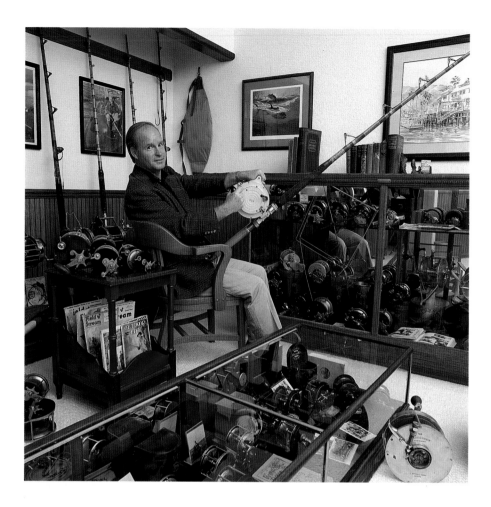

"This outfit was made by C. R. Klein, a Los Angeles custom tackle maker. It was used for marlin, tuna, and broadbill swordfish. Given the techniques of the day, mainly dead-boat fishing, big reels were considered a necessity. Today's anglers use smaller reels, lighter line, and maneuver their boats to catch large fish. These reels were all put together in an era when the world was still largely unexplored from a sport-fishing standpoint. So they were preparing for anything, the ultimate, a world record. They might catch dinks with it. There's no guarantee that you're going to catch a big fish with a big reel, but they always wanted to be ready.

"These reels [ON THE RODS BEHIND FARRIOR] are all custom-made Kavolovsky reels. He charged up to $850 for custom reels, even during the Depression. He was a meticulous machinist. His reels are considered the finest in the world to this day." •

"

What we've put together here is a grouping of 'knucklebuster' reels that typify what the early anglers in Avalon used when they began fishing for tuna. The Tuna Club's original headquarters were at the Hotel Metropole, and they nicknamed the porch the Tuna Hospital. A lot of the members would get banged up. They'd pump these fish sometimes four to seven hours. Sometimes they would dislocate a shoulder when they'd try to hold on.

"The Julius vom Hofe reel, like the one you see in the postcard with Col. Morehouse and his 251 pound fish caught in 1899, is represented on both of the standing rods as well as on the green book [LOWER RIGHT]. It was patented in 1885 and '89. The reel on the leather case with the circular drag is an interesting piece. That is a Gayle made in Frankfort, Kentucky. I have Gayle reels of hard rubber but have never seen another all-metal one of that size. It would have been used for either tarpon or tuna. It is equipped with a 1902-patented Rabbeth handle, which allowed the spool to slip when the handle was held. The center reel [ON YELLOW BOOK] is a Meek #11, also quite rare; I've only seen four of them. That reel at the turn of the century would probably have sold for something on the line of $85 to $95. In the foreground the reel with the leather drag is an Edward vom Hofe, an 1883 patent, also about a tarpon size, that being the largest available then. They would have fished tuna with them here. Just left of that is another Edward vom Hofe, a 1902 patent, developed primarily for tuna and marlin fishing. Note the heavy construction and increased line capacity.

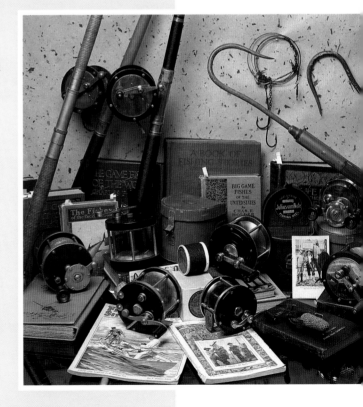

"

Lorinda Bray

Carousel horse restorer

ondition, collectors say, is critical, but when you collect something old, you can't always expect to find it looking like new. The more you possess the skills to put things right, the more broad-minded you can be in considering an acquisition. Lorinda Bray brought the wide-ranging skills of a theater and float designer, book illustrator, and medical photographer to the collecting of carousel horses and taught herself all she needed to become expert in restoration as well.

"The first mechanical ride was a merry-go-round. Traveling in a circle with the wind going past you, it was really a thrill ride. At a time when you couldn't even hold your girlfriend's hand in public, you could take her on a merry-go-round and hold onto her, protect her from this fierce horse on this really thrilling ride. The merry-go-round was a courting ride. The saddles are quite long and accommodate a woman riding sidesaddle or two people riding together. It was never made for children. No, no, it was always an adult ride, and children rode on the benches with the nannies. Now it's become a children's ride, but fortunately more and more people are remembering, and more and more adults are riding them.

103

"My parents used to take me to the carousel, and then we would stand there maybe ten minutes while I chose the horse that I wanted and waited for somebody to get off. You were very careful which one you chose. For me it had to have lots of feathers and flowers or something really wonderful on it. I used to think it would be the best job in the world to get to paint these things. I thought, 'I just want to have my own merry-go-round someday.'

"I started by working on a compendium of carving motifs. I was photographing, I was making drawings, and I was going to put it all in a book. I thought that maybe the manufacturers had certain styles they used and certain motifs they liked. That was proving to be somewhat true, and then I began finding overlaps. Well, you figure it's a business, and three manufacturers carved in New York within a block of one another, and they were all friends. So when one needed help, they all schlepped down and carved for the other guy. Or maybe they ran out of body blanks, so they grabbed a blank from the guy up the street.

"When I started collecting about 1980, I had no idea you could buy these things. I didn't know where to begin looking, and then I saw an advertisement for horses and bought the first one. It's one of those things: you don't know when to quit. And I never have quit, but I certainly don't acquire as I used to. The money supply dwindled. When interest was 23 percent, you couldn't help but make money. Inflation was great for a lot of people, but we all wind up equalized in the end, so now I'm being a lot more frugal. Prices, of course, have been driven up tremendously, and that also takes away your buying power."

"The collector Jim Aten told me that some of his horses exceeded a hundred thousand dollars when he auctioned them off in September 1992."

"But I'm not paying those prices. That's silly. I think you know in your heart what is a good limit, and when things begin to exceed that, you say, 'Well, okey-dokey, I'm done doing that.' I don't ever pay top dollar. I suppose I did when I started, and people gave me a lot of razzing about, you know, why they're so expensive. Now I look at them and say, 'So where are all *your* armored horses?' and they don't have them. I have them.

"You wonder if you don't reach a saturation point, but as with any collection, you want to be as complete as you can. This is not the biggest collection, but it's probably the most complete collection in terms of all the American manufacturers being represented."

"Are there distinctions that collectors make among the manufacturers?"

"There are, and I think it's arbitrary. They value, for example, the Allan Herschell horses at the very bottom of the line, and they put Daniel Muller at the top. Now, the Daniel Mullers really are beautiful—they're probably among the better-proportioned animals—and they're so rare. They only carved four or five merry-go-rounds on their

104

CAROUSEL HORSES

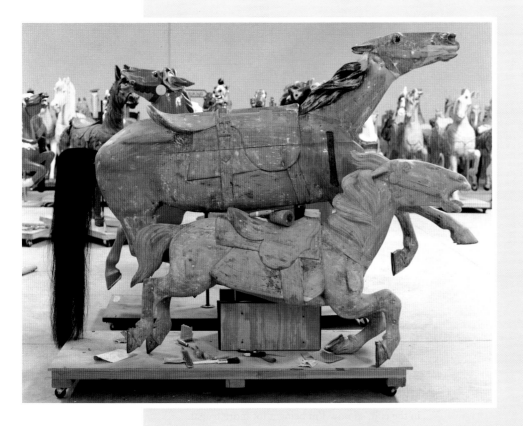

"**T**his Illions horse [REAR] is to me one of the most interesting animals. It's from what they called a derby ride or steeplechase, which was like other carousels but flush to the ground with a cable mechanism underneath that made these animals rush forward and then drop back as the whole thing turned around forty miles an hour. It was so much like a galloping animal that the cavalry used these things to train their people. So this is a horse from that ride. He's been repaired. I think the jawline is incorrect. I know the mouth is incorrect. I found his photograph in a book, this very horse, and he's supposed to have bit rings. The mane I think has been sheared. I bought him just like this, but I really think that he is such a wonderful piece, really long, with that great, big saddle. I think the more comfortable saddle to ride would have been the rear half. The front half, with no support at all, is like riding a park saddle in the woods. I'll tell you, it's not a thrill. [Foreground is an Allan Herschell mustang.]"

own. The Allan Herschells were carved on a tracing lathe, but most manufacturers did remove the bulk of the wood eventually with a tracing lathe, and then there were finish carvers who went in and completed the work. Now, I have thirty-six Allan Herschell horses here, and you can't find a duplicate animal."

"What is typically on the market? The restored ones?"

"It used to be that they generally were unrestored. Then somehow it got to be that restored horses brought more money. Well, this last auction, I've got to tell you, nobody paid for paint jobs. I prefer to buy a horse in distressed condition, where I know what

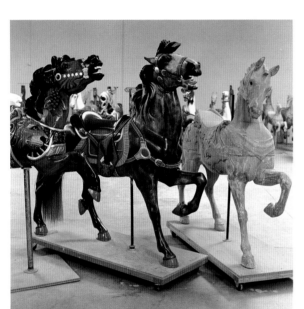

his problems are, than to buy a horse that's been restored and have somebody mask the problems. This little white one is one of the first that I bought, and I got him to teach myself how to restore ponies."

"What are the skills that you have acquired?"

"When I decided to do this, I decided I was only going to use fine materials, so when I do the horses, I only use wood. There is no Bondo. There is no silly putty. There is nothing in there but wood. I take them apart, I add whatever wood needs to be replaced, and then I reassemble them. On this big military Muller [CENTER] from a carousel in Mechanicsburg, Pennsylvania, the eagle was very shallow, the star was almost gone, and this orangey-gold sort of shabrack [saddlecloth] fringe was very, very blurred. I made a tracing of everything and then chopped it off and replaced it with strips of wood and carved it back down. Then I carved into the feathers and brought them up. I made new buckles in the back of the blanket and new bit rings, copies of the original. I can do small things; I don't recarve legs. If it's in really, really bad shape, then I'll send it elsewhere to be worked on.

"The ones in white are in primer. They have been repaired; the wood has been done. They still have little nicks and dings in them, but I repair that on the primer with automotive putty so it's not on the wood."

"The painting is the payoff. You work like a son-of-a-gun getting this stuff done, and the painting is your reward. I document whatever I can find. I take a little magnifying glass and peer into all the little corners. These horses are painted as close to factory colors as I can figure out.

"People don't realize until they get here the tremendous variety of style that there was over perhaps a fifty-year period. Allan Herschell themed their horses as Indian ponies, little mustangs. Then many of them, like the Looff, Illions, and PTC

[Philadelphia Toboggan Company] horses particularly were perhaps the 'grand tour': the king and his charger, the queen's palfrey, the knights' horses, and then the squires' and ladies' horses. Daniel Muller did cavalry, where all his outside row horses were in military attire. Then some of them are just whimsical things. What horse do you know that would carry a flaming torch on his shoulder? The more stuff you had on it, the more glittery it was, the more you could get people to ride them.

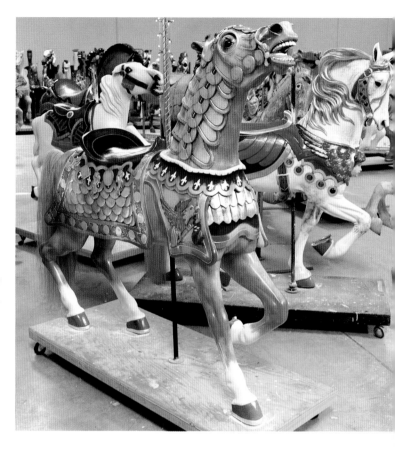

"Remember, these were working things. They were expendable supplies. They were fifty bucks apiece to replace. Sometimes less. It's only been recently that we've realized what wonderful artworks these really are and the craftsmanship that is in them. Yet I'm sure there were time-saving things. They didn't do any shading—I do lots and lots of shading—and when they picked jewels for the horses, I don't think they really spent a lot of time deciding, 'Well, this is a nice color jewel with this color paint.' I think they just grabbed a handful, chopped a hole, slapped them in, and sent it out on the road, because these things were supposed to work, make money, and time in the shop is not time making money."

"There is an end to all this, isn't there?"

"Yes, to move them to a place where we can all enjoy them together. This is not the location for a museum, but eventually I'd like to take all of this some place, maybe get an orange orchard and have ponies there. There are four complete merry-go-rounds here and a blue-goose ride. They're all in parts, but they're all here. There's a little train ride too. And all that could go together with a petting zoo."

"Will the merry-go-rounds be for riding or for looking?"

"There will be three ridable merry-go-rounds. I had originally thought about putting together the merry-go-round that goes with these panels on the ground, but as time progresses and labor costs get so much higher, it probably is more expedient to make that a display of merry-go-round parts and not put those horses on the rides because they'll be in such good condition, I'd hate to have people get up on them and start nicking the paint. I think being able to ride three merry-go-rounds in one place is probably enough. Don't you?" ●

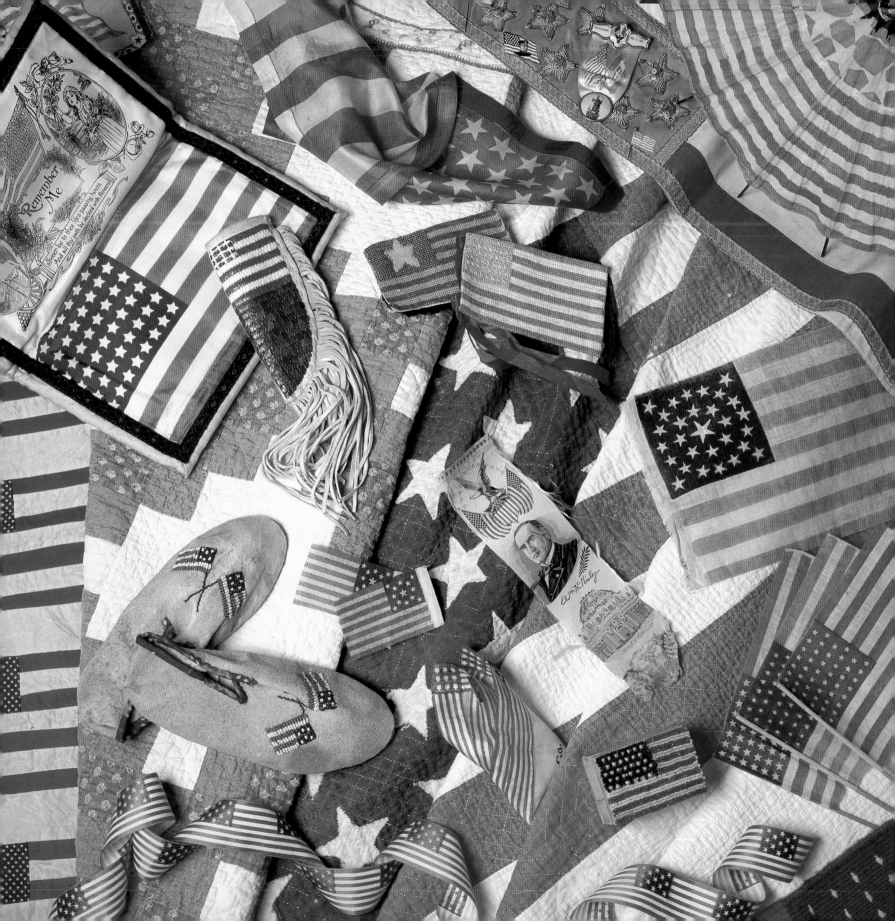

Kit Hinrichs

Graphic designer

veryone knows who made *the first American flag, but credit for its conceptualization—the choice of colors, for instance, or the decision to go with stars instead of polka dots, as in the famous Stan Freberg ditty ("Everybody Wants to Be an Art Director")—may remain forever the subject of debate. The result, however—boldly asymmetrical, vivid, and malleable—has inspired countless graphic artists, trained or untrained, to design versions of their own. In celebration of the centennial of the Statue of Liberty, Kit Hinrichs on behalf of the San Francisco chapter of the American Institute of Graphic Design invited nearly one hundred colleagues to interpret the flag, resulting in* Stars & Stripes, *an exhibition and catalogue. It takes a graphic designer to cast a fresh eye upon something so venerable as Old Glory, seeing it for what it literally is.*

109

"The interesting thing about our flag—in fact, it may be unique among national flags—is that it is changeable and still the same symbol every time. Ours is the only flag in the world that provides that opportunity. That's emblematic of the people, because the system allows change to happen.

"Now, there was a convention almost from the beginning saying there would be white stars on a blue field, but the configuration of the stars themselves changed, and the number of stripes changed. If the proportions of a particular flag were a bit deeper or a bit narrower, the proportions of the stripes changed as well. There were no official guidelines until 1912; really in terms of government-mandated proportions and colors, none until 1934. So you have 150 years of the American public creating its own symbols, and that's also an aspect that I find fascinating. People did and people still do interpretations of the flag.

"This double-sided quilt [PAGE 108] was done in West Virginia during the Civil War. On one side it's a regular quilt: red and green calico squares on a white ground. The other side is a flag with thirty-five stars [for the thirty-five states at the time of the war]. There was obviously a lot of troop movement in West Virginia during the war. The story is, if the Yankees were in town, you'd have the flag on the outside. If the South was in town, you'd have the flag side down.

"There are three Indian pieces here. The sheath is done with quillwork, so my guess is that probably comes out of the Midwest, where porcupine quills were rather commonly used. The moccasins with the beaded flags, I believe, are either Navajo or Hopi. I don't know much about Navajo weavings [LOWER RIGHT], but whatever they saw, they incorporated. It was not a political statement; it was there, they saw it, they incorporated it.

"The sequined sash [TOP, CENTER] I'm assuming would be something that you would be wearing during a parade. It's faded significantly. The lingerie case is for silk stockings. Maybe that's what the doughboys were most interested in at that time, because, again, it's a going-away-to-war, send-it-to-your-girlfriend kind of thing.

"This circus parasol [UPPER RIGHT] is just printed paper. When I bought it, it actually had bands around it, so I would think they were the kind of thing that you would get at a country fair or a circus.

"The needle cases are definitely one-of-a-kind pieces. They have a flag on the front, which is done in beadwork on one and needlepoint on the other, and then the back has

a piece of felt.

"I don't collect a particular manufacturer or a particular vintage. These were all made by the American people. I would say 80 percent of the collection is one-of-a-kind, and of course, the one-of-a-kinds are the most interesting, whether made by a professional or someone experiencing a patriotic outpouring."

"What qualifies an object to be in the collection?"

"Stars and stripes, and usually the flag has to be the predominant element."

"How many are actual flags?"

"I probably have about fifty flags that are real. This forty-six-star flag is just a large,

regular flag from the early twentieth century after the admission of Oklahoma in 1907. Some are big. They're wool. They're hand-embroidered. Others are printed. In this case there are actually two complete stars sewn on each side of the blue field.

"I also have miniature flags that go on car fenders; those are real too, and I may have hundreds of them. And then there's bunting. The hanging against the wall is a quilt that was done as a memorial to William McKinley. You can see his signature stitched in the center of it: '1901 In memoriam Wm. McKinley.' The rest of it is just very simple bunting made into a quilt.

"As all people do when they poke around, I went to an antiques fair. A woman there, who is a great Americana collector, happened to have this up on the wall. It was the end of the day. She'd been there two days and hadn't sold it. I said, 'Boy, that's really wonderful,' and she said, 'Let's make a deal.'"

"The collection began with a flag sewn by my great-great-great aunt in 1866. There wasn't a huge flag industry at that time, and she may have wanted to have an American flag for herself. It may well have had to do with the national spirit at the end of the Civil War, when West Virginia was admitted as a state. It has thirty-six stars."

"So she made a flag representing a reunited nation."

"We kept it folded up in a box under the bed, and when it was Flag Day, my sister and I would trade off taking it to school and holding it up in class. Later when I went to New York after college, Jasper Johns was just coming on the scene with his flag paintings. Not having quite the income to afford a Jasper Johns even in those days, I thought, 'Well, it's only an American flag. I have one of those.' So I had my parents ship it out, and I framed it up, and that was kind of the beginning of the collection.

"I used to collect everything—I still do collect a lot of things; all collectors do—but I needed to focus, and this seemed to be a way of doing that. When you look through flea markets, you say, 'Ah, there's another American flag in another form.'

"There is, obviously, no limit to the forms, the materials, the purposes. There are a lot of individual little, embroidered flags, crocheted flags. A lot of these are printed paper things from Dennison's, but probably a hundred years old. Certainly I have

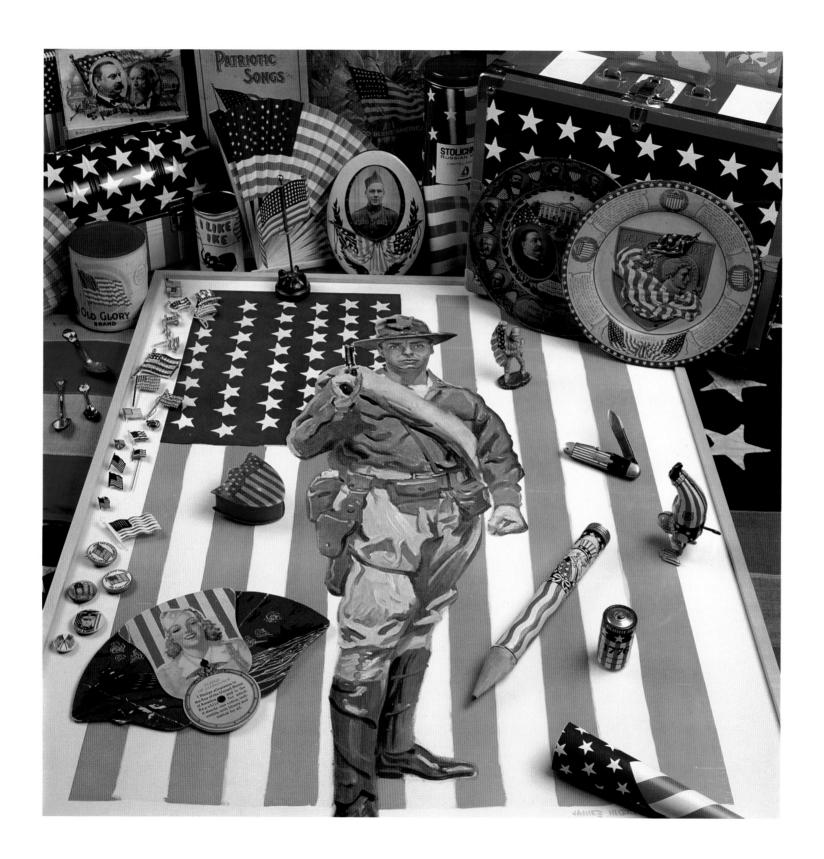

postcards—there's an amazing number of flags on patriotic and holiday postcards—
and things you wear in parades. I've got sweaters, one from Ralph Lauren, and jackets
in that category as well.

"From the lunchbox to the suitcase to the fans, all the little pins, the pincushion—
that little crest shape with the pincushion in the middle—it's that variety of the same
image that I find so amazing.

"Because of the growth of America from the 1880s, 1890s, the tremendous growth in
the number of states, there was a real fervor about the country, so that the American
flag found its way into many more items, probably through the Second World War, than
it has past that time with maybe the exception of the Gulf War.

"Grover Cleveland is on the cigarbox dated 1880. The tin plate [SECOND FROM
RIGHT] is dated 1908 and shows William Howard Taft encircled by all the previous
Republican candidates for the presidency. Every four years you would have those kinds
of commemorative things.

"This is one of the original posters from World War I. I keep wondering if that
wonderful opening shot in Patton is not based on the power of this kind of image. The
picture frame [around a soldier's photograph] is also World War I, and I'm assuming
that before someone went off to war, he would have his picture taken, put into one of
these frames, and sent back to Mom or the girlfriend.

"The little pencil box is full of pencils; you pull off the tip. The little windup clown is
probably from the '40s. The jackknife with the inlaid flag—it is a beauty—again, '40s
or '50s."

"I really look at these things in two ways. Some are commercial ventures, but others are
folk art—and not necessarily patriotic art; often people make them out of protest. I give
a lot of speeches around the country to designers and business audiences. Usually at the
end of the presentation I will show the AIGA flag show in slides set to music. After that
I say, 'If anybody finds something that's under $50, buy it and send it to me, and I'll
send you a check. If it's over $50, send me a Polaroid.' Inevitably people just send them
and say, 'Gee, I thought you'd like this.' They realize, 'I have something,' and they think
of it as having more importance as part of a collection. A well-known photographer
came to me at one point and said, 'I picked this up in West Germany a couple of years
ago, and I thought you might like it.' It was a wonderful flag, but it was a doormat, an
unmistakable political statement." •

Marius Péladeau

Retired art museum director

everal years ago I received a request from Marius Péladeau for a photocopy of an essay long out-of-print concerning a Civil War-era banjo in the collection of the Los Angeles County Museum. He had the acquisition of just such a banjo in mind and wondered about the quintessential features that would distinguish it from one postdating the war. When work began on this book, I remembered Péladeau and contacted him with the idea of including a collector of musical instruments. Only then did I discover that it was not banjos per se but the war itself that obsessed him.

114

"It all started back when I was in college. A friend of mine went hunting with a Civil War musket and came back with a deer. I was quite impressed, because it's only one shot, and it's only about 100 to 150 yards. Subsequently I got very interested in the technology of firearms at that stage in American history, and it just kept going from there.

"Most collectors feel they're collecting something artistic. Here that doesn't apply. This collection is basically technological. The mid-nineteenth century in America is a fascinating period. Technology was changing so rapidly. Elias Howe and the sewing

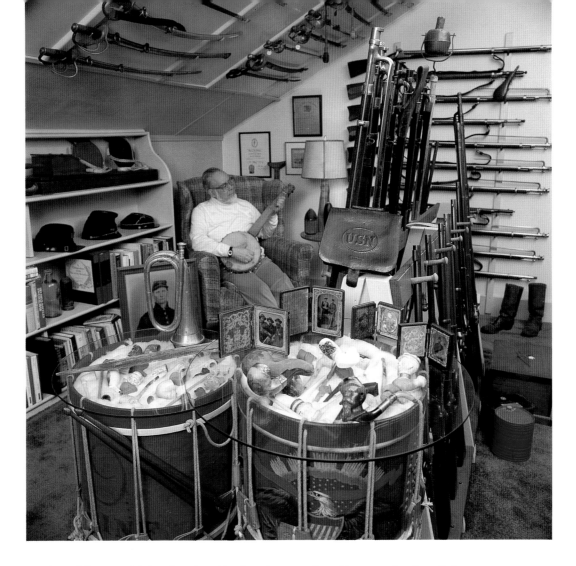

machine did away with hand sewing. Goodyear's patent for rubber came in 1851. Gale
Borden invented evaporated milk. Samuel E. Robbins and Richard S. Lawrence in
Windsor, Vermont, came up with lathes and milling machines so that every part of a
gun could be made exactly like every other."

 "Was completeness a goal in collecting the muskets?"

 "When I knew how many I was aiming for, yes. There aren't that many. Once I got
all the guns that I wanted and most of the swords and had read the books on the
technology of how or why these were made, I started buying other books: Bruce Catton
and that sort. The more you read, the more you get beyond the guns and swords—or at
least I did—into all the other facets of it.

 "What did the soldiers eat? What did a piece of hardtack look like? How did you
make a knife and fork and spoon into a compact unit?

 "You hear sometimes of officers indulging and the enlisted men being upset that the
officers had whiskey. What did a folding corkscrew look like? I dug this one out of a
battlefield in the Wilderness [Virginia].

"How did you fire a cannon?

"A cavalryman is no better than his horse. How did a cavalryman clean the pebbles out of his horse's hoof?

"I've gone digging in battlefields. I found a soldier's spur, which had broken and been lost in battle. So the question became, What did the spur look like when it was whole? What did an officer's spur look like?

"What games did the soldiers play in camp?

"You find a letter that says, 'I had my picture taken. I'm sending it home.' What did their pictures look like?

"Why was the Navy the only service smart enough to think of cotton as a summer uniform? Why did the Army wear wool in Virginia in the summertime? There's your cavalryman's uniform. No idea of camouflage, but by the end of the war officers who had been using gaudy epaulets were getting rid of them and wearing privates' uniforms. General Grant never had a full-dress uniform. He realized he was a target, and he didn't make himself conspicuous with all the gold braid.

"Why did a noncommissioned officer have one kind of sword? Why did a musician have another? Yes, little boys. Why were fourteen- and fifteen-year-old boys dragging that sword along with them? You'll notice the musician's sword is a little shorter.

"The American military mind at the time, 1860, was rooted very deeply in French Napoleonic tactics of fifty to sixty years before. All of a sudden, the breech-loader, which could be fired six or seven or eight times very rapidly, completely changed how men approached the enemy. You no longer did it in ranks as they did at Bunker Hill, but the generals were still thinking of Bunker Hill, and that's why the death tolls were so high. They had graduated in 1820 or 1830 from West Point, where they were taught tactics of the eighteenth century. They couldn't get out of that mind-set until very late in the war, when finally men were given tools to dig trenches. Cavalry no longer charges with this glorious image. Men leave their horses tied to trees and fight dismounted. So it's a period of evolving military tactics, and these things do demonstrate what you read in books."

"*Which comes first: the literature or the objects?*"

"You read the literature, and you see mentions of things. At Point Lookout, Maryland, where there was a big Confederate prisoner-of-war camp, you read that they put the prisoners to work piling sod along the Potomac and Chesapeake Bay to keep the water from eroding this point of land. A friend of mine went down there and found this pointed cypress stick [ON DRUM] driven into the bank, still holding a piece of sod after 130 years. You read things like that, then you go down to the battlefield or you go to the camp, and you say, 'What can I find?'

"In the '50s most people with a metal detector went looking for battlefields; that's the obvious thing. A soldier would throw off his overcoat in the heat of battle. Well, you should find some buttons—and bullets and shells and things of that sort. (There are some people who have whole rooms of dug relics.) Then, as battlefields got picked over, people started looking in the literature for the locations of campsites, because there are always dumps at campsites. They were always reshoeing a horse. They were always throwing away an old piece of equipment for a new piece of equipment. They were always throwing away bottles: patent medicine or whiskey.

"Of course, most of Virginia between Washington and Richmond is becoming subdivision. The National Park Service is buying more and more land, and you can't dig on federal property. So, it's now the luck of the draw: Can you find a friendly farmer in the Shenandoah Valley who doesn't mind your going into his back forty and digging around? I don't do any digging anymore, basically because I don't live down there.

"In the '50s there was very little interest in collecting Civil War memorabilia. You could still knock on the occasional farmhouse door and find the daughter of a Civil War veteran. A lot of these things came directly to me that way. They were happy that somebody was interested. I have a canteen with blood stains on the strap [CENTER, LEFT, PAGE 118]. The lady had always heard that this was Grandfather's canteen; he had been wounded at such-and-such a battle, and his blood had stained the white sling. She had no heirs. She was just so happy that somebody would take it. That used to happen a great deal.

"Now the heirs go to some antique dealer or auctioneer and ask, 'Is this worth anything?' Of course, the auctioneer wants his 10 percent commission, and he'll say, 'Yes, I can get $200 for that.' So there are lots of materials going into the open market, and you have to contend with that."

"How would you describe this collection? It's not the history of the battles or the issues."

"It's the man, the average man. It's not hard to collect Wedgwood or Staffordshire or Jenny Lind's dress because everybody saves that sort of thing. Historical societies or museums save the general's uniform, the general's epaulets, the general's boots and saddle, but the average soldier's stuff never got saved. Most of the stuff I collect is private's stuff. If he brought home his blanket, he would have used it till he wore it out. It had no monetary value; it was just a utilitarian thing. If the guy went to war and bought a package of tobacco, if he brought it home, which is very unlikely, he would have smoked it within a year or two. So to find a package of tobacco without the revenue stamp, which only came in 1864, is very unusual. That's why the everyday soldier's stuff intrigues me."

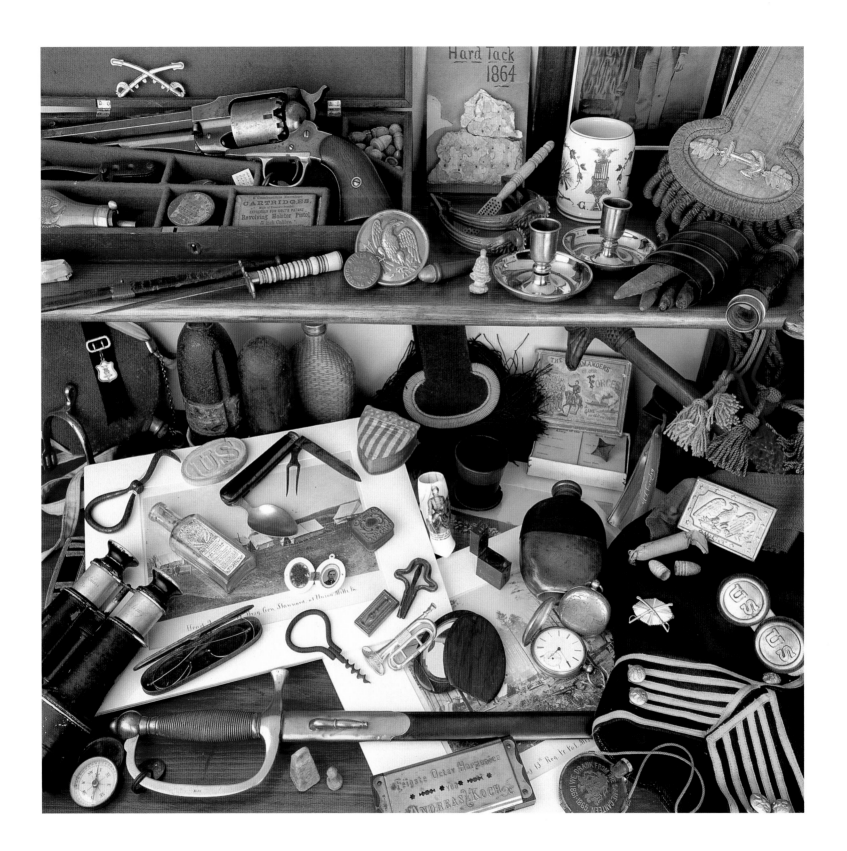

"Is this an uncommon private Civil War collection?"

"I think it's uncommon in its generality. I think if you went to another Civil War collector, you would find all shells or all muskets or all swords or all uniforms. I just happen to be a generalist. A little bit of everything, and it just keeps going and going. A whiskey flask that was carried by a surgeon in the 8th Vermont; his name is on it. There's what's left of a piece of hardtack. Pocket watches. Photographs and more photographs. One Mathew Brady print is the only known copy. The number of traveling inkwells is just endless. A toothbrush that was dug up near Kernstown, Virginia; toothbrushes haven't changed much. Chewing tobacco. Stamp boxes so your stamps wouldn't get all sweaty. It's a nostalgia in the twentieth century for something that's gone—partly. And it's true that you find things basically better made then than now.

"Every collector of the period prizes more highly something that has an inscription on it. Anything that actually has proof of Civil War usage. This pipe [FOREGROUND, ON DRUM, PAGE 115]. It's a very beautiful pipe—probably made in Germany or France, New York importer—and this guy's initials are right here: A.P.P.: Alfred P. Patterson. He was a sailor, and why he didn't stay at sea, I don't know, because he ended up getting killed at Petersburg when he was in the 28th Maine. This other pipe just has eagles on it, and you could say it's mid-nineteenth century by design and patriotic by overlay, but I can't prove this was carried by a Civil War soldier. It's only an example of the type."

"Does a director of a museum bring a certain perspective to collecting that other collectors might not have?"

"If you've ever been a museum director, you know there's nothing worse than getting a gift and having the donor become the curator of that gift. When I give this to a museum, my question is not going to be, 'How often are you going to display it?' but 'How well are you going to take care of it in storage?' Because I realize it's a study collection. You just don't do a display of Vermont guns every six months.

"I don't know if most people think about what's going to happen to their collections after they pass away. It would be interesting to know if they do. Of course, you can always sell it and have the proceeds go into something for your wife or husband. But I've made provision for part of this to go to Vermont historical museums, basically because 75 percent of the room is Vermont and I'm from Vermont originally. In fact, I have partly assembled it with that idea in mind.

"It would be interesting to find somebody in their mid- to late twenties who is starting to collect something at a price which older people find absolutely outrageous. If the dollar is immaterial, if they're one of these double-income households, it would still take them longer. It's just not as easy to find. If I take 75 percent of my collection off the market and will it to a Vermont historical institution, that makes a difference." ●

Mark Wiskow

Antiques and collectibles dealer

Many collectors pursue their obsessions
with the kind of zeal that defines the
word vocation. Mark Wiskow, whose
vocation is collection—on behalf of
customers actual and potential—
has met his own obsession with the
charming nonchalance that puts the
a *in* avocation. *True, as dealers in
California and other potteries, he and
his wife, Susan Strommer, have assembled an array of hand-thrown pieces that within
its area of specialization would be hard to equal, but it is now in his avocational
collecting that he appears to take the keenest interest.*

"We shop for a living, and like anything you do everyday, it can get to be a drag.
We may go out one day and find something perfectly good in a Lalique bowl for cheap.
We're going to make a lot of money on it, but it doesn't thrill me. It's work. It's my
job. But the same day I may find a really cool diver for $1.50, and it gives me a lift.
I like to collect stuff that's cheap and that amuses me. Do I have it? Is it cute? Is it
cheap? Those are my criteria.

"This aquarium furniture amuses me. It reminds me of my childhood. Or, it reminds
me of an idealized childhood. It's not so much a memory as a wish of a memory.
Before I was old enough for school, my parents took me to see Ringling Bros. Circus.

121

I remember riding home on the bus from New York City with a turtle in a cardboard box, a live turtle we bought at the circus. The next day we got a little plastic bowl with a palm tree and a castle. A couple of years ago I saw one of those castles. It was under a buck, and I thought, 'Well, that's cool.' Now here we are, and I've got 150 of them.

"Most of the time when you find one, it's in a thrift store or an estate or garage sale. Usually they're dirt cheap. Occasionally they're at flea markets with the kind of dealers who don't throw anything away. Sometimes people walk up to me and hand me little bags. I ask them, 'What do you want for that?' and they just grin and shake their heads. 'If you're weird enough to collect it, you can have it.'

"Real or imagined, there was a demand for these things, and they sold in places that sold goldfish bowls. You can still buy them in pet stores. If you're going to get into breeding tropical fish, you need a place for the babies to hide, or the other fish will eat them. That's the main purpose of these things: a place for little fish to hide from bigger fish. Others are aerators, to oxygenate the water so the fish don't suffocate.

"The variety is incredible. Sometimes the workmanship is also incredible. Occasionally you'll find them with windows cut by hand or separately molded pieces. That's a lot of work to sell for twenty-nine cents. Most of the older ones are Japanese, I have to guess postwar. Some say, 'Occupied Japan.' A few of them are American.

"Most of the decoration is fanciful: castles and divers and mermaids. A lot of the mermaid and bathing beauty designs go back to 1870, 1880. The highest-priced ones on the market are German. A good German bisque mermaid, even very small, can be two or three hundred bucks.

"I myself don't care about aquariums. You have to clean the damned things all the time. The poor girl across the street: I see her out there every three weeks with her spaghetti pots and her gravel and her hose and her scrub. But I'll tell you, when I'm out shopping, say, I'm at a flea market, and I spot an aquarium, I light up. Where's the toys?" ●

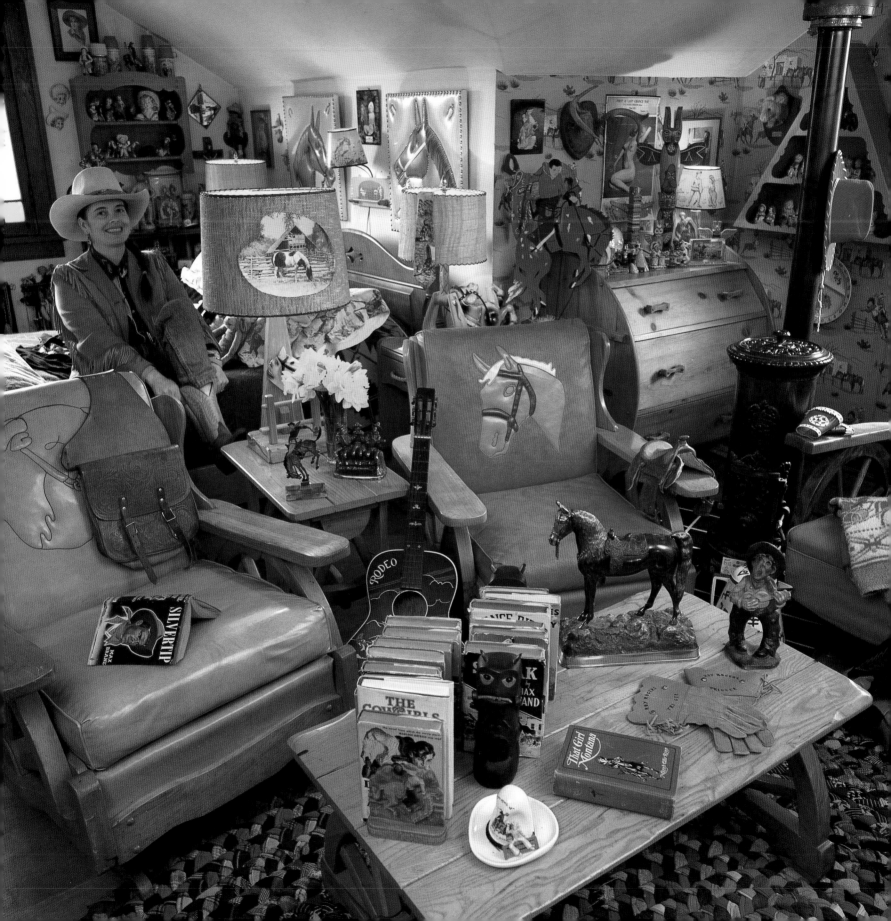

Ruby Montana

Proprietor, Ruby Montana's Pinto Pony

Wild West

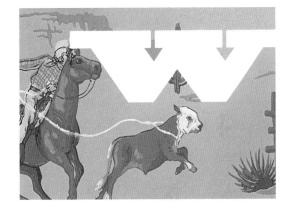

hen Ruby Montana confessed a
preference for Roy Rogers over Hoppy,
I was shaken from the top of my
Stetson to the tips of my Tony Lamas.
Such unabashed heresy requires some
mighty fast talking, but Ruby is quick
on the draw. "I'm gonzo for all those
guys, but I think that Roy was more
user-friendly, always associated in my
mind with Nellybelle [his sidekick's jeep] and Trigger and Dale. It seems like he was
surrounded by friends, whereas Hopalong Cassidy seemed a little more aloof in that big,
black outfit on that tall, white horse."

"And the others? Gene Autry?"

"Oh, Gene Autry was just an incredible guy, but I always thought of him as a melody
man. I'd say if there was cool, that was Hoppy, but if there was a handshake and a guy
that really liked kids, it was Roy Rogers."

Ruby Montana collects cowboy—and sells cowboy too through her mail-order
catalogue and in her Seattle store.

"I collect *Hollywood* cowboy. I'm not into bunkhouse. I don't collect horseshoes and
saddle bits and that kind of stuff. That's real cowboy. I prefer vinyl palomino heads and
the funny little lamps from some kid's room in 1942, stuff like that.

"I assign heart to my things. I play with my stuff all the time. I set up dioramas.

125

Tell me about the salt and peppers."

"They're all anthropomorphized cacti, and they're kind of incredible. On a scale of one to ten, almost all of these are about a nine, maybe some of them ten, in particular the sheriff and his bustiered woman on the bottom. I've only seen that set maybe twice in a lifetime of beating the streets for salt and peppers. I'm in the national salt and pepper shakers club, and I buy hundreds of collections, and I haven't seen very many anthropomorphic cactuses."

"How about the KK?"

"That's Kaye Kershaw's brand from the Double K Mountain Ranch."

"And the wallpaper? It's perfect for a kid's room, yet does that mean it was made for a kid's room?"

"I think the wallpaper was meant for kids, but I also think it's going to appeal to a lot of people. If that wallpaper were available right now, you couldn't even keep it in stock."

"Do you think the interest in Wild West among the general public is a passing fancy?"

"I don't think at the level it's operating at right now it's going to continue as the focal point for fashion, but it's like I just have to think that people are always going to be fascinated with the cowboy and the cowgirl. The American West is always going to hold the general public. It's the great adventure.

I really find it enjoyable, and, of course, part of it is keeping the child in me alive. It's like that in the store too. So for the most part it feels like I'm having fun when I'm working. I never wake up in the morning and think, 'Oh, God, I've gotta go in today.' I really look forward to it.

"I feel like I'm very influenced by spirit whether it be from a horse or a funky folk art painting. I collect things that I feel fit together and put them together from my heart. I definitely feel like the spirit of the West is part of why I came here. I like adventure. I rode freight trains for years. Freight trains are like having your own picture window to the world. I set up a room that, when I wake up, kind of makes me feel like I could go jump on a freight train. It's kind of me, so to speak.

"Those saddlebags [LEFT, PAGE 124] belonged to Kaye Kershaw, who owned the Double K Mountain Ranch. She's just a marvelous woman. She taught Justice William O. Douglas and the world how to shoot and quarter moose. She rode a Harley and in the '20s was repairing her own airplanes, then singelhandedly built her ranch. That's why most of Washington was enamored with her. And, of course, she wasn't available to men, so that was another side of her that was interesting. With her girlfriend, Isabel, she pretty singlehandedly saved the wilderness area around Chinook Pass. Remarkable women. Those saddlebags were a gift from Isabel in the early '50s. That piece has so much heart. If I were racing out of the house, if it was about to go up in flames, what would I grab? That's one way to look at it.

"Spirit appeals to me: the symbol of the cowgirl, the rodeo cowgirl. Most women were lucky to more or less get beyond their children. I'm drawn to anybody that broke the mold. For me that's the kind of person, whether it be male or female, that is appealing, somebody that has very little fear of taboo.

"That lamp [CENTER, LEFT] is a favorite too. I was driving down the road from the Oklahoma City airport. It was late on one of those days when I felt, 'Oh, my God, I'm going to miss all the shopping,' and suddenly I saw this antique mall. I jumped out of the car, and that lamp was there. You have to realize that the name of my shop is the Pinto Pony, and that lamp has a pinto pony photo shade. It's like the ultimate thing. And great nostalgic barn. I about died.

"Beneath the lamp is another incredible piece. It's from the Pendleton Rodeo of 1932, and it's in fabulous condition. It even still has a paper label on the bottom with the names of all the winners."

"Is there a distinction between your personal collection and what's for sale in the store?"

"Oh, absolutely. There are some things that I just don't part with, but I feel like I'm the humane society for things. I have to find good homes for them, because I can't crowd everything in here, even though it may look like I've tried. You can see why a

person like me would just have to have a store, because you'd explode out of a room and even ten rooms in a real hurry. It's great having a store because it's like an extension of my home, and I can continue to buy from my heart and sell to people, not for gouging prices, but just to give them the kind of joy I'm experiencing. I love it.

"All my obsessions took me to the point where I couldn't really do a full-time job away from them. I was just having so much fun, it would have been hard to continue working and not focusing on that. It's kind of like any art form, I suppose, and I consider it an art form."

"*What were those obsessions?*"

"Well, certainly tropical obsessions—flamingos—and the Western obsessions, the salt and peppers, the cookie jars, and snowdomes. I've gone through several obsessions that have changed to some degree. I mean, I was a classical musician for some years. I played French horn.

"You change as you grow and enjoy your life. I feel that's a part of it too. It's like working through things, a lot of these obsessions. It's like reading a good book from start to finish. You take things away from a book, but you're not going to live with every chapter every minute. I may have collected spinner lamps voraciously at one point, but then I'll only keep the six best ones. I may have collected thousands of salt and peppers and kept only my thousand favorite. I may have collected every cookie jar in the world, and then what you see are only the Flintstones. I mean, you kind of learn what is really hard in anything. Hard to find as well as the stuff that really gasses you personally. You have to really love it, because collecting is an effort, so it has to just be alive in you."

"*What are the Western items that are most popular in the store?*"

"I'd have to say things like vintage Roy Rogers and Hopalong Cassidy lunch pails and lots of the little vintage jewelry pieces. I just sold a beautiful set of shoes and a bag that were cowhide. Shoes like that at Nordstrom's would probably run you $225, and you can buy that right out of my store window for $85 for the shoes and bag. And if they fit, you're just a styling babe. I'm really in love with lots of the little kids' Western gear, and it does exceedingly well in the shop as long as I'm willing to sell it. There are many, many items that I'm not willing to sell."

"*Do you know if you're buying for yourself or for the shop?*"

"Yes, but occasionally I'll live with something a day at the shop, and I'll go, 'Oh, no, I've got to take it home.' And occasionally I'll outgrow something at home and take it down to the shop."

"*Is it all endlessly recycling?*"

"Totally. It's a lifestyle, not a hobby. I live and breathe it, and I absolutely love it." ●

Mike Stella

Computer analyst

hereas others are quick to acknowledge the role that nostalgia plays in impelling them to collect, reminding us of the discontinuity in most lives between past and present, there is no such discontinuity in the life of Mike Stella. Toy trains are his life—past, present, and future.

"I always played with trains as a kid, never lost the interest, but junior-high age I traded all my childhood Lionel trains and went into S-scale electric trains. In high school I sold all of those and went into HO, which is what the majority of model railroaders in the world today build. When I was in the navy, the first few years in the navy, I still built kits, sent them home, went home on leave, and played with my trains. I never stopped buying. Overseas I could still buy trains through the mail. I'd have them sent FPO San Francisco. I was getting trains sent to me in the Gulf of Tonkin. I was fortunate enough to be on an aircraft-carrier-size ship, where space was not a problem. I had storage galore, so we set them up and played with them quite often. That brings you up to 1970, when I started back collecting the Lionels. So I've gone a complete circle.

"The Space Age killed toy trains for a decade. That combined with the proliferation of television. Lionel, the company that had been in business since 1900, sold out to General Foods Corporation in 1970, and they started producing trains in one of their

130

subsidiaries in Michigan. You're looking probably at only one-third of the production since 1970. I ran out of space many years ago.

"The original Lionel Co. may have run a car for twenty years, year after year, made a little improvement, modified as manufacturing changed, but basically it was the same identical car for twenty years. People might collect that for whatever reason, but they didn't go buy one every year. Now Lionel keeps a train in the line one year only. This is why the collection gets so big so fast. Most of it is paint changing. Very seldom do they come out with a new die and a piece that's absolutely new.

"So the collectors have been asking for twenty years: Does the Lionel Co. exist for collectors, or does the company exist for the general public and just happen to make things that the collectors are interested in? For twenty years everybody has said Lionel exists for the collectors; it would

not exist if it weren't for the collectors. It's producing $2,000 engines, $2,500 Smithsonian-issue engines. Who's going to buy those? The guy who goes to Toy 'R' Us for his kids? No, no.

"From 1970 till about 1988 I bought everything Lionel made. Everything you see on this wall [thirty-six feet long, seventeen shelves high] was purchased by me brand-new. Much of it came out of the box and went onto the shelf, and the only reason I don't run and play with it is because I've got too many other things I can run and play with. I get enjoyment out of looking at that wall, looking at it like a painting, but if somebody said, 'Let's take one upstairs and run it,' there's no taboo against that.

"To some people just being out of the box decreases the value as opposed to still being sealed in Saran Wrap."

"How much joy can you get from something that's sealed in Saran Wrap?"

"You're doing the study on collectors. You tell me. How much joy do you get out of an automobile that you never drive?"

"People say, 'How many can you run?' Well, I can only run one, but I have spots set up with electrical panels where I can put people all over the room, five or six all in that loop from Point A to Point B, and when it gets to the end, you can turn it around and send it the other way. It's a lot more interesting for me than just watching trains run around in circles.

"I can come up here and take a train out of this yard. It'll go up and over the mountains, come down, run around the whole room, change directions by going through the center section, go around the room the opposite way once more, and end up in the second city yard over here, never being on the same track twice. It takes about five, six minutes just running it, but when it's in operation, it's going to take about fifteen minutes to get from Point A to Point B. You're going to have to follow a schedule. You're going to have to make station stops and switch cars and do everything like a real railroad does. That's what the whole point of it was. We drove the gold spike last May when we completed the ability to run from Point A to Point B.

"It was all laid out in my mind and on paper, a lot of it, before a single piece of wood was cut or screwed, and it's pretty much come out exactly the way we envisioned it ten years ago. The scenery is done the cheapest way possible. If you look up under the mountain, you'll see an interwoven bunch of cardboard strips, and I just glue it with a hot-glue gun. Then I cover it with papier-mâché, using wallpaper paste; I learned a long time ago you don't use flour and water because the mice eat it. Then you cover that with a layer of plaster. A good friend has done all of my mountains. He'd go out and do rock castings with latex rubber. Then we put them in different places and plaster around them. He's done all the painting—on the mountains.

"Through him I met another person. I went over to his house one day, and he was showing me some of his paintings, and I said, 'Could you do that on a wall?' He said, 'Yeah, I think so.' He's been coming over for two years now, and he's almost done. The last thing he completed was the circus over there.

"The one part that we have not gotten to yet on the layout is the accessories. Everything here is going to do something. The ice house will load ice cubes. The helicopters will fly. The coal loaders will load and dump coal. The forklift will actually unload the lumber. The horses will walk around the corral. The station has a record player in it which announces the arrival and departure of trains. Log loaders lift the logs and load the logs. Everything that looks like it should light up does light up."

"When you have a goal like I have, which is everything that Lionel made, you can't help but get some of the very, very rare, rare, rare things as well as all of the common things.

"There's something usually different about every single train, and sometimes it's as simple as they changed colors of stamping, or they heat-stamped them in silver paint or

rubber-stamped them in white paint. They look identical except for that, but that's a specific change in their manufacturing process. Some of them have the magnets that hold them to the track, some of them don't. Some of them smoke and whistle, and some of them don't. Little differences. A lot of times they changed the actual production number on the engine, so it makes it very easy. If you've got a number 123, you know it's different from a number 124, but there are those kinds of things where a 123 and a 123 and a 123 all look identical, but they actually are different.

"Here's a good example. This is a 726 Berkshire engine, 1946 [BACK ROW, LEFT], and here's another 726, 1947–49. A lot of people would say that's the same engine, but you can see that these are hand-turned stanchions right here [on the 1946], and these are cotter pins right here [on the other]. When you look at the cab, you can see they're not the same at all.

"When the Korean War broke out, there was a shortage of alnico metal, which they had used in magnets on later models, so they reverted to the 726, and when they did, they denoted the fact by putting a little "RR" under the engine. 1952. Subtle differences.

"The blue engines that look identical are Chesapeake & Ohio. The only difference between those to the naked eye is the number, but one of those engines [no. 2365] is worth $300; the other is worth $2,000, because one was only available through a Sears Christmas set one year, and the other was a general catalogue manufactured item.

"The same thing with the two engines on the next track just behind that, the black and orange ones. You see one has the orange going all the way through under the windows [RIGHT]; the other does not. Again, about a $1,700 difference.

"The minute somebody says, 'There are only ten of these variations known to exist,' somebody'll find an eleventh. All the time that happens. Too many people are labeled experts, and they know an awful lot, but they don't know everything. You know, you have a company that was manufacturing hundreds of thousands of toy trains. If on Monday they ran out of green paint, did they stop production and send everybody

home? No, they might have switched to blue paint for the rest of the day, and so they made a very few blue ones, and nobody knew it. And that kind of stuff is turning up even today.

"There are variations in plastic cars which can make one car cost $5,000 and another car cost $10. I don't have a lot of those $5,000 cars yet. There are two or three that I will get. I will pay that amount of money to get them, but I won't do it for all of them. So I never will have a 100 percent complete collection, but it will be because I've reached the point I want to reach: I will have every major variation, every major color variation, every major lettering variation, etc., etc. In 1947 they used brass rivets, and in 1948 they used steel rivets, therefore, 'you've gotta go get one of each.' No, I don't go into it in that detail. But if in 1946 they painted it red and in 1947 they painted it blue, to me that's worth going after.

"Rarity is probably the biggest factor. The other thing is supply and demand, which doesn't always mean rarity. It might be generally considered common, but everybody wants one, so the price goes up and up and up. On the other hand, there are some items that I've been looking for for five years and have never been able to find, and when I do, it's a $10 item. Nobody else is looking for it. Nobody else cares. They're not going to want it till I get my hands on one, and then I publish an article nationwide that says, 'Hey, look what I got and how rare it is.' That's how I've come onto certain things too because other people have done articles saying, 'This thing is real rare. You ought to go find one.'

"I'm not a box collector. I don't care if it's brand new in the box. If it's in the box, it's going to come out of the box. A lot of rare, rare items become extremely valuable when they're in pristine condition and become very, very inexpensive when they're not. That's not one of my criteria, that it has to be pristine, so therefore I can amass things in a lesser-quality grade and be just as happy as the person who collects new-in-the-box.

"The trains downstairs [on the wall] I bought new. Most of these on the model railroad come from garage sales. They come from train meets. They come from trade magazines, auctions, wherever I can find them. I have feelers out all the time saying, 'I'm looking for one of these. Whenever you find one, give me a call.'

"The trade papers, the trade sheets, the buy-sell trade sheets of all the organizations are probably the best source of finding a lot of trains you're looking for. Advanced collectors as well as beginners, if they're lucky, find a club in the beginning years. I can run a want ad nationwide to go to 25,000 collectors and hope to get a letter saying, 'I got what you're looking for.' You couldn't do that without the train clubs.

"The clubs are probably the single most important thing to the majority of train collectors. They set the grading standards and add continuity. If a collector in New York calls me up and says he's got a train in XYZ condition, I know exactly what he's talking

"On a lot of layouts there might be ten or twelve concentric loops of track, and the guy can turn on ten trains, and you watch them all go around in circles. The first layout I had when we moved into this house was the concentric loops. I could turn on all my trains, they could run around, and it drove me nuts, and I said, 'I'm going to do what I've always wanted,' which is what this is. This is not your typical layout. This is a railroad, a model railroad. It runs from Point A, City A, to Point B, City B, and if you put a train on the track and just left it, it eventually would hit the end and crash onto the floor because the track does not run around in a big loop. It has a starting spot, a middle part, and an ending spot.**

"

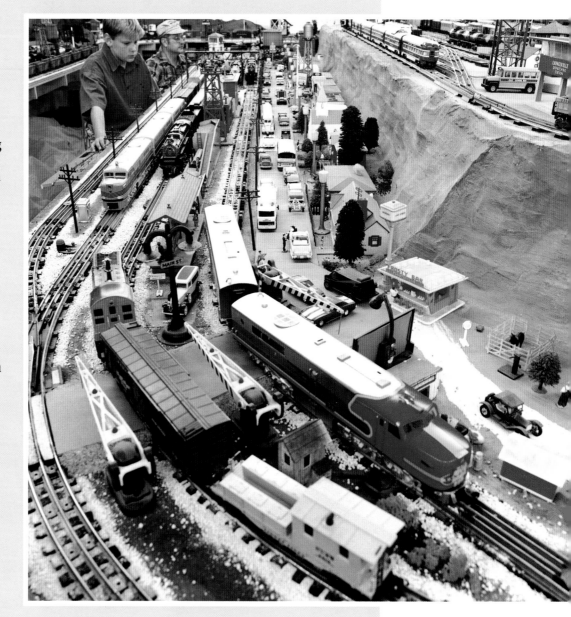

about because the organizations have set the standards, and he's using them, and I'm using them. The clubs also provide meets where the majority of people are train people. They provide conventions. They provide token convention cars and things made especially for the clubs.

"And there's another advantage to belonging to the club. If I order from New York, the guy says it's excellent, and he sends it to me, and I say it's not excellent, the club is there to ensure that I get my money back or I get some kind of rebate. I can physically take the thing to a committee and say, 'You look at it. What is it?' and they will determine—oh, absolutely—and arbitrate that. And if there's still a problem getting your money back, the person could lose his membership over the whole thing, and most people don't want to do that.

"I've been doing this for twenty-two years. It's a thrill to get something you've been looking for for four, five, six years, never seen. In my collecting today it's very rarely a case of finance. It's not a case of 'I can't write a check for a thousand dollars and buy the thing that I don't have.' It's a case of 'the thing I don't have I've never seen for sale at any price.' So, when you do find one and you'd pay $1,000 for it, and it's only $10, I mean, you know, what a high! It's just fabulous. And the only thing that's more fabulous than that is when you share it with other collectors who appreciate what it is that you got for $10 or whatever the price. It doesn't matter what the price. It's the fact that you have it.

"Still you do it for thirty, forty years, and you wonder what the heck's going to become of it when you are gone if you don't have somebody to pass it on to that has the passion for it. It's not just the interest. It's the passion, because that's what it takes to appreciate it and to either keep it going or just keep it where it's at. I mean, who wants to inherit 350 Studebakers unless they really, really love Studebakers? The trains are the same way. Somebody inherits these trains, they might have one or two that they want to keep forever and set around a Christmas tree. But what do you need with 5,000 trains? You've really gotta have a passion for them.

"And so a museum is the only way a lot of people feel that you can keep it together. If you donate it to some city on the condition that it's open to the public if only a few times a year, at least it doesn't disintegrate. I'm sure dolls are that way. I'm sure anybody's collection is that way. You have the feeling 'Why am I doing it anyway?' It's probably like asking a drug addict why he does crack. When he knows it's killing him, why does he do it? This is my drug habit. I don't know why." •

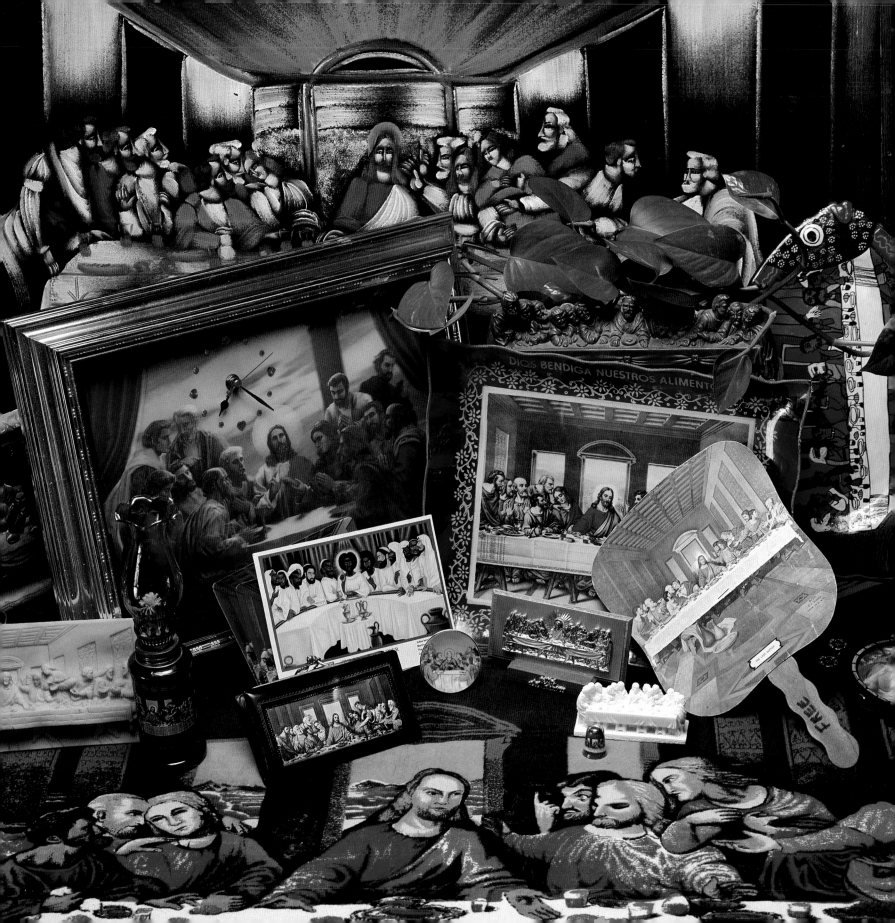

Susan Caroselli

Museum curator

he unique aspect of this collection is that the collector didn't collect it. "I'm not really a collector in that sense." Of more than 150 objects in what a wide circle of friends calls the Caroselli Collection, Susan Caroselli has acquired only three: two postcards and a holographic plaque. "Except for these pieces, everything has been given to me."

Indeed, the collection started with a gift, "a funeral home fan, which, as you can see, didn't cost a lot; it says 'free' on the handle. I'd never seen a funeral home fan in my life. A lot of the Southern churches have them, but in New England"—Caroselli is from Boston—"in the Congregational church they didn't care if you were hot; you just sat there.

"When I turned the fan over, I discovered it was from a funeral home in Everett, Massachusetts, which is where I lived the first two years of my life. So I thought, 'This is of cosmic significance obviously.'"

The picture on the front was equally significant. "My training was in Italian Renaissance art history. I lived in Milan for a while, and I did a lot of work on Leonardo da Vinci and was interested in the iconography of the Last Supper."

Caroselli was delighted with the gift. "I showed it to everybody I worked with—

I worked at the Detroit Institute of Arts then—and they got such a big kick out of it that a couple of them went out and started to find things. Before I moved to L.A. [in 1982 to work in the Department of European Sculpture and Decorative Arts at the Los Angeles County Museum of Art], I had three or four pieces," including a cedar plaque, one of six similar plaques now in the collection, with a reproduction of Leonardo's painting laminated to one side and thickly coated with acrylic.

"The first Christmas I was here, I thought just for fun I'd put up the pieces. At the time, we were reinstalling the entire permanent collection in the European and American galleries at the museum, and I was spending most of my days writing labels for all the objects. I was in a label-writing mode, so I said, 'Well, if I'm going to display these and pretend they're art, I should do museum labels for them.' That first party just exploded into gifts for me from all over the place.

"People loved the idea of having their names on the labels [in imitation of the donors' names that traditionally appear on museum labels], and so they would go out and try to find these things. They would go to the *botanicas* and the places with religious art. They were going all over the city to try to find a Last Supper so they could be in the collection.

"Now once a year, usually at Christmastime, I have an opening to which I invite all the donors and everybody else I can think of. There have been in this apartment at one time 130 people, which is really a very large number to put in this space. I have the labels up on the wall, so people who are donors bring their friends because they want them to see what they've given to the collection.

"It may be of interest that at least four of the pieces have been given to me by priests, one of whom will probably be a bishop sooner or later and may live to regret that she made a donation.

"There are two main Last Supper images that we now know. The most familiar, of course, is the da Vinci. I would say 75 percent of my pieces are based on that one, but the Peter Paul Rubens is also very popular. It's a more compressed image, so it's easier to accommodate on an object. You see it on some of the 3D postcards and on that little, bitty plate [CENTER, PAGE 138]. It's interesting because you've got the balance [in the da Vinci], the classical balance of the long line at the table, and [in the Rubens] you've got the grouping of people in a variety of poses. So they're taken from the two contrasting examples, the Renaissance and the Baroque.

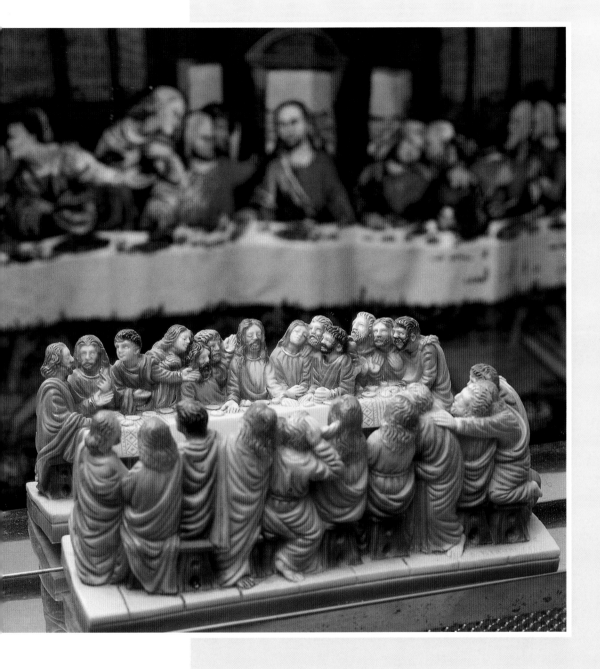

"This, of course, helps you see what the back of the Last Supper looks like, because, since Leonardo didn't paint the back, we never knew. There are different interpretations as to what was going on and who was sitting and who was standing and what they were sitting on. Here they're all sitting on stools, except there aren't enough stools to go around, so someone suggested perhaps they were playing musical chairs and that's why Judas left early, because he lost on the first go-round."

"I've broken the collection down into four major categories. There's sculpture. There are objects, or *objets*—if you want to be high tone—textiles, and then panels, which takes in not only paintings but anything that's flat that's not a relief sculpture or a textile. I've got five…actually I think I have six of the Last Suppers on slabs of cedar ranging from one that's about sixteen inches long to one that's about four inches long. I have the paint-by-numbers that my mother did; I'm very proud of that. Did I mention the thimble my father gave me? Finally I've got one on black velvet. This was a long time coming. It was found in an abandoned house in West Hollywood. It was the only thing left in the house.

"I have several that are iridescent, including one that is actually quite alarming if you get it in certain lights. I have one embossed on copper and two in which the Apostles are all black. I also have photographs of two reenactments of the Last Supper.

"There are a few in molded plaster or some strange substance that I haven't been able to identify. The one that's still wrapped up in plastic, that's the wax one, which was made by the candlemaker to the cathedral in Munich. The whole thing is wax, even the frame. You could burn that. In fact, the hanger on the back is made out of wick material. On the label—my label, not the label that came with it—it suggests that you put a wick in each one of the heads and burn them on a daily basis.

"I have plates of various sizes and a number of funeral home fans and two foil trays from Ensenada in a variety of colors and pressed glass—a large and a small. Then I've got two plastic tablecloths and two pieces of Nottingham lace. This is an embroidered dish towel. And this! Remember liquid embroidery?

"I've got some more textiles…and more textiles…and more textiles. A stereopticon card. A trivet. Two clocks: one embossed; the other, 3D. It was given to me by two women that I sing with in the choir at All Saints Church in Beverly Hills. I was so astonished when I got it, just the idea that it's 3D and a clock and it has these little heart-shaped indicators for 12 and 3 and 6 and 9. This is a unique object.

"The Last Supper is a painting. It's a very famous painting, and people have done just the most extraordinary things with this image. It's not that the image is the least bit humorous, but the fact that they've chosen to put the image on such unlikely things as a wallet or a refrigerator magnet is just amazing.

"You were asking if I myself am religious. During the arts festival that took place, not during the Olympics, but two years later, part of the collection was displayed in the lobby of the West Coast Repertory Theater up on Hollywood [Boulevard]. A couple of people, somebody who was producing a play there and one of the actors, said they were offended by it. I had always known that there would be people who might be offended by it, but this was the first time it had gone public. So I wrote a disclaimer, which said essentially that these works of art were not intended to make fun of the sacrament of the Eucharist, which I believed in very, very devoutly, but that they made fun of what had been done to a great work of art that happened to have a religious theme as its subject.

I was hoping that that would get around that. But I still realize there are many, many people who have bought these things out of devotion, and I know that there are some people who would not understand that I was showing them and that people were amused by the collection. So that's something I always have to take into consideration. That's also why I've never really gone public since.

"About a year ago I made my will—that's always a good thing to do, because you never know— and I thought, 'What am I going to do with this collection?' I knew I could will it to LACMA [Los Angeles County Museum of Art], but they wouldn't take it. So I thought what I would like to do is, I would get my executor to return all the items to the donors, and let them deal with them! That would be a fitting retribution." ●

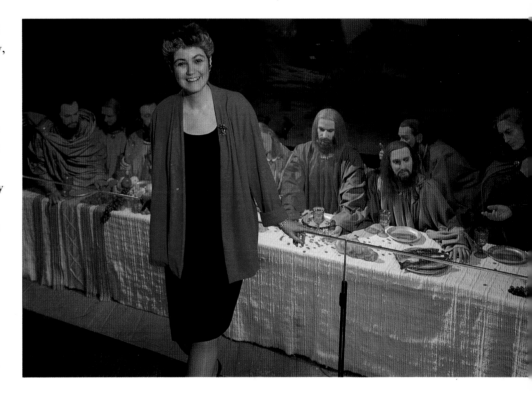